IMAGES
of America

MARITIME
CONTRA COSTA
COUNTY

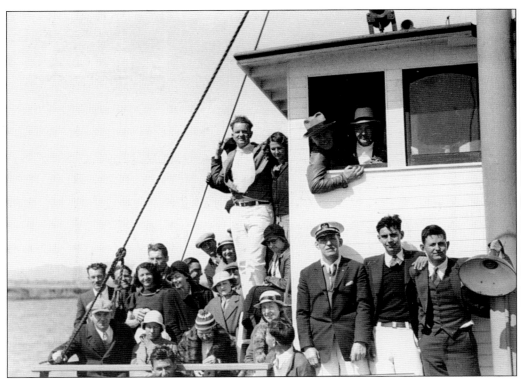

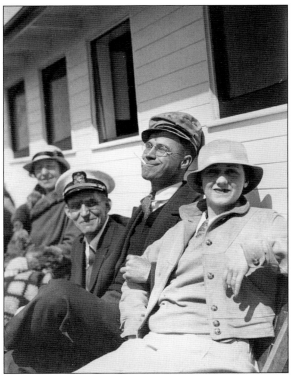

ON THE COVER AND LEFT: The full-size image from the cover appears above. The little passenger-and-cargo ship *Spig* departs from Pittsburg for Stockton for an excursion day around 1926. On board are "Swede, Elise, Mom, Liz, Allie, Andy, Flo, Hern, and Elsie," all in celebration mood and enjoying a busman's holiday from their regular maritime-focused lives. At left, Pop and Allie bask in the morning sun en route to Stockton. He is arm in arm with Allie, and Pop's face tells it all: Life is sweet cruising along the Contra Costa County coastline. (Both, Pittsburg Historical Society.)

IMAGES
of America

MARITIME
CONTRA COSTA
COUNTY

Carol A. Jensen
East Contra Costa Historical Society

ARCADIA
PUBLISHING

Published by Arcadia Publishing
Charleston, South Carolina

Printed in the United States of America

Library of Congress Control Number: 2012953883

For all general information, please contact Arcadia Publishing:
Telephone 843-853-2070
Fax 843-853-0044
E-mail sales@arcadiapublishing.com
For customer service and orders:
Toll-Free 1-888-313-2665

Visit us on the Internet at www.arcadiapublishing.com

To "Judy, Judy, Judy"—memorable paraphrase of Cary Grant
in Only Angels Have Wings, Columbia Pictures (1939)

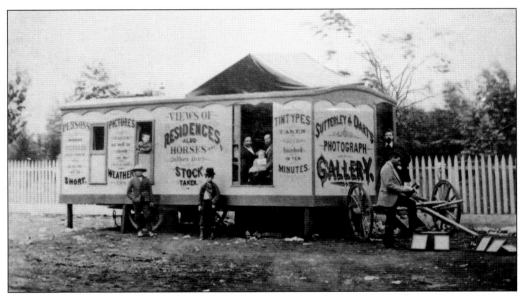

Persons, pictures, views, tintypes! Do not forget life along the river. Sutterley & Dart, itinerant partners in photography, traveled throughout Contra Costa County from 1875 to 1881, capturing domestic and commercial scenes. Their photography studio wagon doubled as a mobile portrait studio, glass plate developing room, and mobile home from 1875 to 1881. These pioneers traveled throughout the county through Concord, Pacheco, Martinez, Clayton, Antioch, Nortonville, and Point of Timber. (Contra Costa County History Center.)

CONTENTS

Acknowledgments 6

Introduction 7

1. Frontier and Empire 11

2. Ferry and Transport 19

3. Fishing and Timber 39

4. Farming and Packing 57

5. Factory and Mining 71

6. Foreign Wars and Home Front 89

7. Fun and Fame 103

8. Future and Environment 121

Bibliography and Additional Resources 126

About the East Contra Costa Historical Society 127

ACKNOWLEDGMENTS

Tom Trost of Bethel Island instigated the writing of this little book and encouraged the telling of this maritime story. Once the premise was devised, all the local shoreline historical societies scoured their collections for content. Warm appreciation goes to the following organizations and their staff members: executive director Priscilla Couden of the Contra Costa History Center and its Louis S. Stein Photographic Collection enhanced the quality and quantity of images included herein; the capable Contra Costa History Center volunteers, especially, were a great help; the Pittsburg Historical Society, Edmund Caruso, president, and Rosemarie DiMaggio, curator, and Frank DeRosa provided wonderful fishing industry images; Kathleen Correia, California State Library; Jeff Thomas, San Francisco History Center–San Francisco Public Library; Debra Kaufman and Mary Morganti, California Historical Society Library and Archives; Carole Ann Davis, curator, and her assistant, Laura Jacques, Antioch Historical Society; Melinda McCrary, curator, Richmond Museum of History; and Jim and Joyce Metcalf, Rio Vista Museum. Kathy Leighton of the East Contra Costa Historical Society continues to inspire me to find and write about a local history niche. Thank you, one and all!

Members of the San Francisco Bay Area Postcard Club (www.postcard.org) were most helpful and added images from their personal collections for inclusion. My gratitude is extended particularly to club member Ken Prag of San Francisco for generously allowing use of his Contra Costa collection, Ted Miles, club member and curator of the San Francisco Maritime National Historical Park Library Collections, and Glenn Koch. Gina Bardi, librarian at the San Francisco Maritime Museum Library, was particularly enthusiastic about the project and kept me motivated. FedEx Office staff members Leticia Montgomery and Amelia Braga aided in the oversize-image scanning.

Finally, many individuals too numerous to list have been most generous in their encouragement and support. Robert Chandler's mantra rings in my ears: "Nothing counts until it is written down." Thanks go to Jared Nelson, Arcadia Publishing acquisitions editor, for his continuing interest in the San Francisco Bay and delta. The aid and patience of the irreplaceable Robert D. Haines Jr., cannot be overstated. Writing is impossible without the excellent and thorough copy editor extraordinaire, Marcy Protteau. The errors and omissions in the writing are all mine.

Please contact the author at the e-mail address Historian@ByronHotSprings.com or through one of the above referenced historical societies if you can contribute to our maritime Contra Costa County history with an oral history, family documents, letters, photographs, or ephemera.

All images are from the author's personal collection except where indicated. The following organizations and collections generously allowed the use of their images: Antioch Historical Society (AHS); Bancroft Library, University of California, Berkeley (BANC); California Historical Society, San Francisco (CHS); California State Library, California History Room, Sacramento (CSL); Contra Costa County History Center (CCCH); East Contra Costa Historical Society (ECCHS); Glenn Koch (GK), Liberty Union High School District (LIB), Sam Mathews of the *Tracy Press* (SM), Dean McCloud (DM); Pleasant Hill Public Library (PH); Ken Pragg, private collection (KP); Pittsburg Historical Society (PIT); Richmond Museum of History (RICH); Rio Vista Museum (RV); San Francisco Maritime National Historical Park Library Collection (NPS); San Francisco Public Library, History Room, San Francisco (SFPL); United States Library of Congress, Washington, DC (LOC); and the United States National Archives, Bethesda, Maryland (NA).

INTRODUCTION

On August 5, 1775, the Spanish frigate *San Cárlos*, commanded by Don Juan Manuel de Ayala y Aranza, sailed through the Golden Gate and opened California to the commerce of the world. The maritime history of San Francisco Bay begins with Ayala's survey and exploration of the region by ship, launch, and a redwood cayuco—a canoe or dugout. The strong tides drove the party to the *contra costa*—the "opposite shore"—where the course of our maritime history begins.

According to the *Oxford Encyclopedia of Maritime History*, maritime history is the broad overarching subject that includes fishing, whaling, international maritime law, naval history, the history of ships, ship design, shipbuilding, the history of navigation, the history of the various maritime-related sciences (oceanography, cartography, hydrography, and so forth), sea exploration, maritime economics and trade, shipping, yachting, seaside resorts, the history of lighthouses and aids to navigation, maritime themes in literature, maritime themes in art, the social history of sailors and passengers, and sea-related communities. Contra Costa County embraces all of this in its 240-year history. This maritime history covers the economic history of the region, from Native American trade to modern water rights wars.

Maritime Contra Costa County history touches upon the many defining maritime subject areas, but focuses primarily on the use of the area's vast waterways in commerce. The waterway along the county shore is the liquid highway that links all agricultural, industrial, and commercial endeavors to "executive headquarters" in San Francisco. The land directly east of San Francisco comprises over 70 miles of deepwater moorage and over 1,000 miles of navigable waterways. The village of Yerba Buena and later the city of San Francisco stood sentinel to goods flowing in, out, and by Contra Costa. Minerals, munitions, and melons all rolled from the sides of Mount Diablo and the Sierra Nevada along the Contra Costa shore for transshipment out the Golden Gate. All shipping historically paid duties to San Francisco and profits made from this commerce enriched city businesses.

The San Francisco Bay is the largest freshwater estuary in the West and the mythological Eden for the prehistoric Windmiller Culture and its post–Spanish discovery tribal descendants. Abundant freshwater and wetlands provided a bounty that could be traded up and down rivers, tributaries, and creeks. Numerous shell mounds and habitation sites along the shore are still visible today. Indigenous peoples traded up and down the state most easily by water. An estimated 310,000 native people engaged in commerce in the 1770s.

Spanish, Mexican, Russian, and Yankee immigrants overwhelmed California, culminating in the United States' assumption of sovereignty in reparation payment for the Mexican–American War in 1848. "The world rushed in," a phrase aptly coined by historian and author James Holliday, describes the human tsunami that arrived in the San Francisco Bay Area soon after gold was discovered in January 1848. Sam Brannan proclaimed on the streets of San Francisco, "Gold! Gold found on the American River." Brannan himself did not move to the Mother Lode; instead, he departed to Contra Costa to secure his real estate holdings. The true riches to be made during the Gold Rush were in providing the commodities necessary to support and feed the Argonauts in the 1850s. Even more riches were to be made from industries supporting hard rock mining of the Comstock Lode, in Virginia City, Nevada, from 1860 to 1900. These support industries were primarily located along the shore of Contra Costa County.

The first industries to locate on the opposite shore were those requiring large tracts of land for cattle raising, easy bounty from the water, inexpensive sources of power (water), or those that used manufacturing processes too dangerous for densely populated areas. Dr. John Marsh, the first European settler of interior California, began raising "California dollars" (cattle for hides) at his Rancho de los Polpones in 1836. Marsh experienced an unexpected windfall in 1850 when the demand for fresh meat by the miners induced him to drive a 50,000-head cattle herd into the Sierra

Nevada foothills. Heretofore, meat, with limited demand for consumption and no refrigeration, had been just a wasted by-product of his cattle hide business. Hides were bundled and shipped around South America to leather manufacturers in New England prior to the 1850s.

Mussels, clams, oysters, shrimp, and fish were harvested from both fresh and bay water for San Francisco boardinghouse tables and restaurants. Sicilian families immigrating to California soon established themselves in Pittsburg. From here, families radiated along the Contra Costa shoreline from Martinez to Oakley. In Pittsburg and Antioch, they established a thriving commercial fresh fish industry focusing on salmon. Pre-refrigeration canning technology, first developed in 1810 as a solution for feeding Napoleonic troops, was commonplace by the late 19th century. Wild Pacific salmon were commercially harvested in the delta until doing so was outlawed in 1958. Commercial canning of fish from the delta ended in 1934.

Abraham Dubois Starr situated one of California's first flour mills in 1884 in Wheatport, now Crockett. Here, the vast dry wheat farming production of the San Joaquin delta could be milled into flour and exported by water to the world. In the 1870s and 1880s, more bushels of wheat were produced in the upper San Joaquin Valley, including eastern Contra Costa County, than anywhere else in the United States. Much of the flour baked into bread and pastry fed California's growing population. But barley was also exported for malt. What ingredient from California makes Dublin's "Guinness great beer" and San Francisco's "Anchor Steam great beer" after all? Headquarters for Starr & Co. and the subsequent Sperry Flour Mill operation is San Francisco.

Finally, San Francisco shot maker and smelter Thomas H. Selby expanded his smelting and lead manufacturing operation to Contra Costa near present-day Rodeo in the 1870s. Giant Powder Works, Hercules Powder Company, and DuPont opened black powder, nitroglycerin, and dynamite manufacturing companies along the then desolate shore. Blasting materials opened up the California Mother Lode, cleared tunnels for the transcontinental railroad through the Sierra Nevada, and pulverized hard rock deep in the Washoe Mountains of Nevada. Company towns of uniform architecture and design sprang up around these industrial sites, creating some of our first suburban communities. Suburban in this context means less urban than San Francisco. Many of these manufacturers would thrive by providing the munitions used during the Spanish-American War, World War I, World War II, and the Korean War, only to shut down in the 1970s due to the effects they were having on the environment.

In the post–Vietnam War years, Contra Costa's role as an industrial and manufacturing center decreased. Shipyards and railroad Pullman car shops were converted to American Standard ceramic plants and Ford Motors assembly plants. Now, these industrial employment jobs are essentially overseas. The presence of industries benefitting from and associated with maritime transport is greatly reduced in Contra Costa. Only the Martinez and Richmond shoreline oil refineries look to ocean tanker transport. Steel arrives by ship from China to Pittsburg to be cold rolled and transported out by railroad. There are no more hot steel furnaces in Contra Costa. However, many headquarters staff, attorneys, accountants, and investment bankers remain in San Francisco.

The heyday of Contra Costa's role in the maritime trade is in the past. Shoreline today is primarily valued for its environmental, ecological, recreational, and residential real estate merits. Oceangoing vessels mostly pass it by en route to the agricultural inland ports of Stockton and Sacramento. Freshwater not diverted to Southern California holds back some of the saline infusion from the ocean.

Organizations including Save the Bay, the Wetlands Project, East Bay Regional Parks, Contra Costa Fish and Wildlife Committee, and the other Contra Costa County advisory committees are doing their parts to ensure the Contra Costa County Bay and delta coast continues to be an ecologically and economically flourishing shoreline through the 21st century and beyond. Private citizens, nonprofit organizations, and government agencies are working together to ensure our estuary retains its beauty and ecological status while supporting the local economy. I hope you will enjoy this look back into Contra Costa County's maritime history in photographs. Please consider how you can help to ensure our legacy endures.

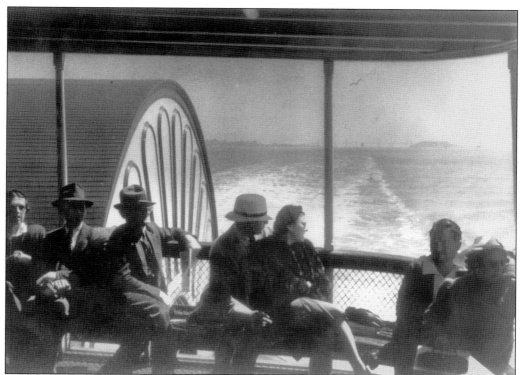

Last-trip celebrants (above) enjoy the view from the fantail as the *Delta Queen* makes her last excursion from San Francisco to Sacramento in 1940. The city of Oakland skyline, the Oakland–San Francisco Bay Bridge, and Yerba Buena Island are in the background as the elegant riverboat steams along the Contra Costa County shoreline. The *Delta Queen* riders are tracing the water route from San Francisco to Sacramento (below) as taken by the forty-niners. Gold-seekers transshipped east by inland transport to Sacramento and into the Mother Lode. Conversely, original transcontinental railroad passengers traveling west in 1869 detrained the Central Pacific in Sacramento to travel the last leg by river steamer. (Above, RV.)

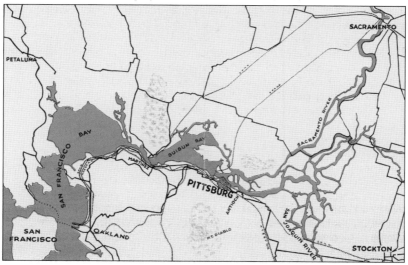

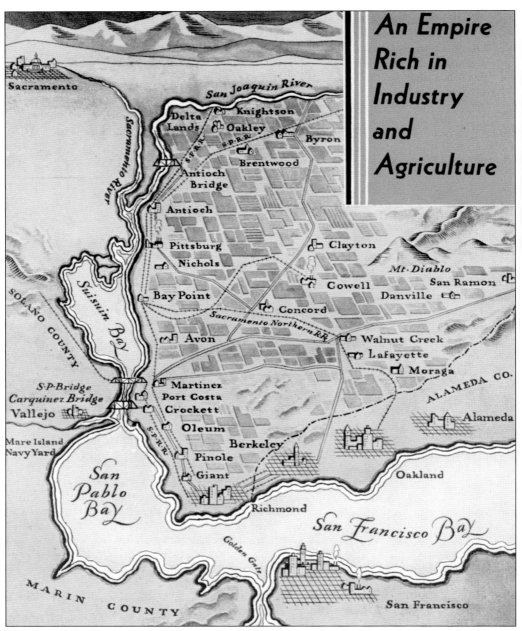

An Empire
Rich in
Industry
and
Agriculture

This fanciful bird's-eye view of Country Costa County from the northwest emphasizes the county's shoreline, relationship to San Francisco, and main river highway to the state capital. All of the major cities in this 1920s booster map border the 120-mile river and bay waterway. This map includes the coastal portion of Alameda County as it was described in de Anza's exploration. He named the *contra* (opposite) *costa* (coast) across from Yerba Buena and today's San Francisco peninsula. Alameda County was part of the original Contra Costa County as first incorporated in 1850. The Contra Costa County Department of Publicity and the Contra Costa County Board of Supervisors encourage all who visit and/or relocate to Contra Costa that its charm is "Factory, Fireside, and Farm."

One

FRONTIER AND EMPIRE

Overland exploration of the Contra Costa shoreline—or "opposite shore"—by the Spanish military and Franciscan friars was concurrent with Ayala's bay survey. Pedro Fages and Father Juan Crespi, under direction from Father Junípero Serra and King Carlos II of Spain, explored Contra Costa County in March 1772. Eventually, all of Contra Costa surrounding Mount Diablo came under the sphere of influence of Mission San José. Mexican independence from Spain in 1810 and the subsequent Secularization Act of 1833 granted large tracts of land to important Californios, thereby securing their allegiance to the new nation. The first such important pioneer to settle the great inland areas east of Mount Diablo was Dr. John Marsh in 1836. Marsh was a Harvard-educated Massachusetts man moving west with the United States. His $100 value in cattle hides earned while a physician at El Pueblo de Nuestra Señora la Reina de Los Angeles de Porciúncula paid for the 14,000-acre Rancho los Meganos in 1837.

Seven years later, Swiss immigrant John Sutter and his small flotilla, manned by Peruvians, Hawaiians, and a 19-year-old captain, sailed the Contra Costa shore, past Marsh's Landing (present-day Antioch), and on to the San Joaquin River, having missed the Sacramento River cutoff. Fortunately, ribbons tied to the tule rushes allowed the three boats to retrace their route and continue their journey north. The founding and importance of Sutter's Fort, his timber mill partnership with John Marshall, and the discovery of gold at Coloma triggered an influx of immigrants (who would later be known as forty-niners) to California in 1849.

It is no exaggeration to say that every Argonaut destined for the northern or southern mines of California's Mother Lode went via the Contra Costa water route. Many who arrived too late for the easy placer pickings would travel back via the same route. Often, these men would take up once more the vocations they had before their quests for gold. They farmed in the rich bottomland of the California delta, built commercial salmon fisheries, and milled grain to feed thousands of immigrants. John Marsh drove 50,000 head of cattle from his Rancho los Meganos to the Sierra foothill mines in 1850 to feed the miners. Later, black powder, nitroglycerin, and dynamite manufactured by Hercules, Giant, and DuPont blasted the way for the Central Pacific Railroad through the Sierra Nevada. True wealth in California was often found in the goods and food produced in Contra Costa.

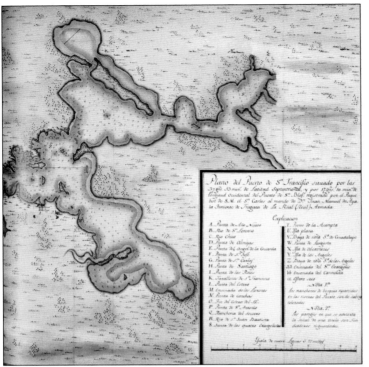

On August 5, 1775, the Spanish frigate *San Cárlos*, commanded by Don Juan Manuel de Ayala y Aranza, entered San Francisco Bay. Its pilot, José de Cañizares y Suárez (1676–1750), embarked with 10 men in a launch to explore and sound the bay. Their first stop was the opposite shore across the bay from San Francisco. Cañizares returned in 1776 to help establish El Presidio Royal de San Francisco and created this second, colorized map. (BANC.)

The accuracy of Cañizares's 1776 cartography is amazing when compared to this modern bird's-eye view of San Francisco Bay, taken 200 years after the bay's first maritime survey. In this image, readers can trace the entire Contra Costa coastline, noting the shallows, main channel, straits, and forbidding tule marshes inland of what was considered an unexplored and forbidding inland sea.

It took great courage to explore and venture inland from the early established Spanish outposts of Sonoma, Yerba Buena, and El Presidio. The Native American population, loosely identified by Europeans as Coastal Miwok, Patwin, Ohlone, and Polpones, became neophytes to the Catholic Church. Those who resisted capture and enforced servitude at the missions fought back and retreated deeper into the protection of the Sacramento–San Joaquin delta wetlands.

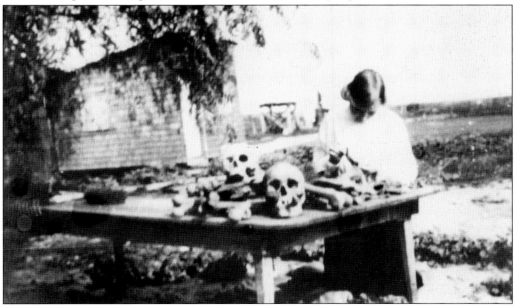

An estimated 300,000 indigenous people lived in California in 1770. By the time Capt. Charles W. Lent's daughter, Virginia, displayed her collection of bones at Point of Timber Landing (around 1910), less than 20,000 of these people remained. There are shell mounds and middens located throughout the shoreline. The state today still has the largest population of Native Americans, with over 100 federally registered tribes. (ECCHS.)

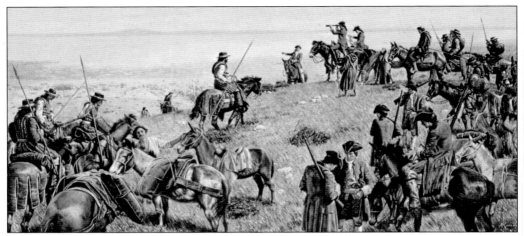

Juan Bautista de Anza (1736–1788) explored the shoreline of Contra Costa during his overland expedition in 1776. His exploration team was the first to witness and officially confirm that California was not an island, as described on maps since 1650. The imagined great inland sea was actually the San Joaquin Valley.

The Capt. Pedro Fages and Father Juan Crespi expedition in 1772 predated de Anza's by four years and set the stage for subsequent Spanish exploration. The Bay Point Historical Society plans a monument here overlooking the present-day city of Bay Point, the easternmost point reached by the Fages-Crespi expedition, in 2015. For more information, please visit www.BayPointHistoricalSociety.com. (DM.)

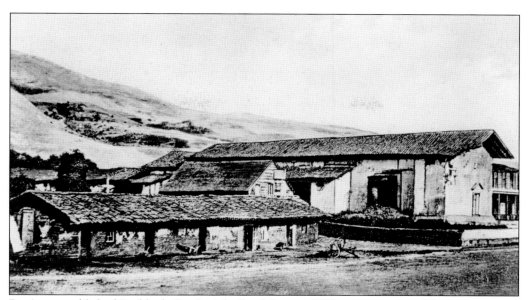

De Anza established Pueblo de San José de Guadalupe in 1777 as an agricultural depot supporting Presidios San Francisco and Monterey. The Franciscan fathers a generation later established La Misión del Gloriosísimo Patriarca Señor San José in 1797 in the present-day city of Fremont. All of the East Bay lands as explored by DeAnza and radiating from Mount Diablo fell under the mission's sphere of influence. It had the largest population (1,886 in 1831) and one of the largest agricultural productions of all the missions. (LOC.)

One of the most popular methods of keeping local history alive is through reenactments and living history days. The DeAnza Trail Bicentennial Horse Ride of 1977, retracing the expedition's journey throughout California, left a lasting legacy. The Juan Bautista de Anza National Historic Trail is traveled by car and individually reenacted by California parents and schoolchildren every year. (PIT.)

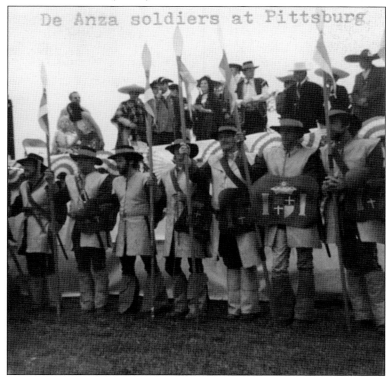

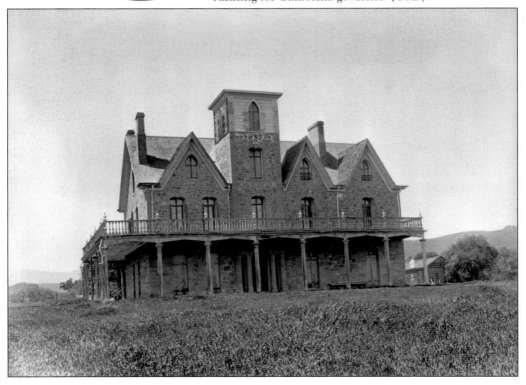

The first European to settle in Contra Costa County was Dr. John Marsh (1799–1856), shown here with his wife, Abbey, and daughter, Alice, in 1856. Hailed as the bravest man in California, Marsh purchased his Rancho los Megaños from José de la Guerra y Noriega. It was the first rancho established outside of "civilization," as it was known in 1837. (BANC.)

Marsh originally built an adobe house and employed the local Polpones tribe members who had been released from their neophyte status with Mission San José thanks to the Mexican Government Secularization Act of 1833. It is here that the first overland settlers arrived from the United States at Marsh's urging. The three-story stone house was built at the height of Marsh's wealth and influence in 1856 as he contemplated running for California governor. (CSL.)

The most prominent Contra Costa landmark, visible from the Farallon Islands to the Sierra Nevada, is Mount Diablo. This drawing from the east emphasizes the vastness of the swamplands and islands in East County, in 1860 and as today. As long as a person can see the "Little Mountain," as it was referred to by Kit Carson in 1846, it is said that he or she will not become lost.

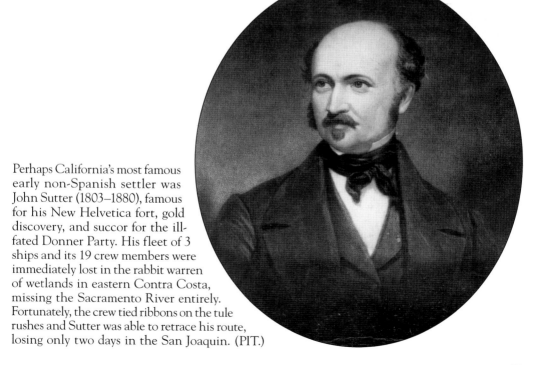

Perhaps California's most famous early non-Spanish settler was John Sutter (1803–1880), famous for his New Helvetica fort, gold discovery, and succor for the ill-fated Donner Party. His fleet of 3 ships and its 19 crew members were immediately lost in the rabbit warren of wetlands in eastern Contra Costa, missing the Sacramento River entirely. Fortunately, the crew tied ribbons on the tule rushes and Sutter was able to retrace his route, losing only two days in the San Joaquin. (PIT.)

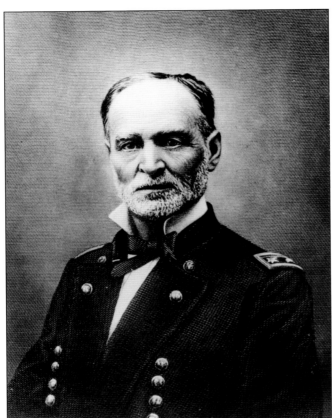

William Tecumseh Sherman (1820–1891), the famous Civil War Union general, has Contra Costa roots. Sherman, as a young lieutenant stationed in Monterey, was engaged in 1849 by William and Joseph Smith, purchasers of the Los Medaños land grant, to survey and map the proposed town of "New York of the Pacific," today's city of Pittsburg. (PIT.)

The Smith brothers, who founded "New York of the Pacific," acquired the land for its 10 miles of river frontage. As this 1849 navigation chart of Carquinez, Suisun, and Hurricane Bays shows, shallow draft ships can reach the inland landings. The Smith brothers' purchase was prescient, as coal was discovered south of New York of the Pacific and the town name was changed quickly to Black Diamond. (DM.)

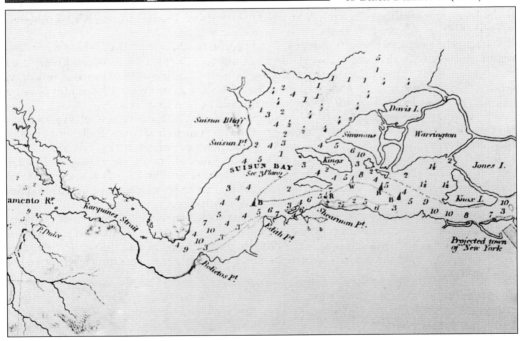

Two

FERRY AND TRANSPORT

In 1850, if a traveler had funds and was in a hurry and fearless, he or she arrived in California by ship. John Sutter arrived by ship and followed the tule rushes along the Contra Costa coast, missing the Sacramento River. Argonauts in a rush to the northern mines took a steamer to the jumping-off point of Sacramento City. Miners heading to the southern mines would ferry to Stockton to get to Copperopolis and Mariposa. Fully half of those arriving at the mines would return to their homes in the American East. Those remaining would in all likelihood return to their pre-mining vocations when mining proved to be fruitless. Twenty percent of these onetime miners and their dependents found themselves in Contra Costa County.

Initially, the side-wheel steamboat transported people, goods, and products along the inland waterways. Stern-wheelers, requiring as little as a three-foot draft fully loaded, quickly replaced them. These ships were ideal for entering shallow estuaries, loading sacks of produce, refloating at high tide, and reversing to regain deep water. Key to economic success in 19th-century Contra Costa was a water landing ensuring that products could make it to market.

Sail-powered potato barges and scow schooners provided slow, inexpensive, and reliable transport of coal, grain, and produce for transshipment to the San Francisco wharves. Each wharf had its specialty or particular destination. The Grain Wharf accepted wheat, barley, rye, and oats for unloading from riverboats onto seagoing vessels. The wharf at Point Orient, near Richmond, specialized in goods headed for Asia. The wharves at China Basin, San Francisco, also specialized in transshipment of cargo to Asia. Unlike today's container ships, which arrive in Oakland full and leave empty, ships in 1880 left San Francisco Bay with cargo.

Commuter ferries reflected the changing suburban and residential role of Bay Area cities. Southern Pacific Railroad's fleet of ferries transported people, railcars, electric trains, and automobiles before the bay was bridged, beginning in the 1910s. Immensely popular with the public, commuter ferries have withstood the modern automobile trend and continue to be a subsidized commuter alternative today.

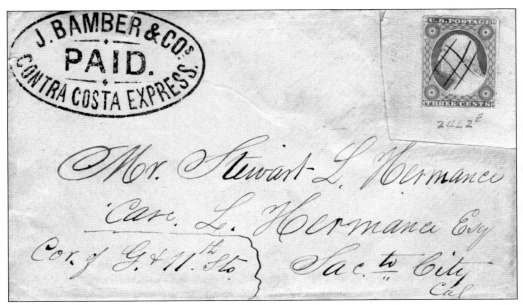

GILPATRICK'S EXPRESS,

TO AND FROM SAN FRANCISCO,

AND THE FOLLOWING POINTS :

Antioch, Pittsburg Landing, Black Diamond Landing. Martinez, Benicia, Vallejo, Sonoma. Petaluma, Berkeley and Newark. Connecting with Somersville, Nortonville and Clayton.

General Office, 305 Battery street, S. F.

BAGGAGE AND PACKAGES delivered and called for at any part of the City. Purchases, Sales, Commission and Collections made at any point on the route. Orders left at the Office or on the Boats, will receive prompt attention.

J. B. SMITH, Agent, Martinez.

Gillpatrick's Express provided the services in Contra Costa County that are often associated with the better-known Wells Fargo & Co. Its representatives collected debts, delivered the US mail, accepted remittances, ferried passengers, and transported payrolls. (PIT.)

J. Bamber's Contra Costa Express consolidated several San Francisco Bay express companies into one in 1858, including Gillpatrick's Express route to Contra Costa County. This envelope addressed to Sacramento is franked from San Francisco.

The *Parthenius* provided consistent passenger and mail service to the major landings along the Contra Costa shore for decades. It was essentially the only way to get to Contra Costa in the 1870s. J.W. Gillpatrick owned the Contra Costa Express, advertising that the ship left Front Street Wharf at 3:30 p.m. and Antioch at 6:00 a.m. daily. (PIT.)

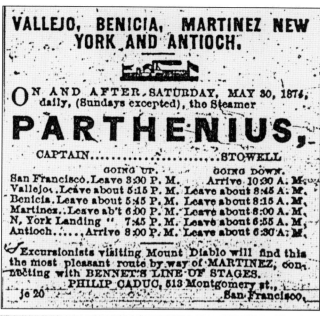

VALLEJO, BENICIA, MARTINEZ NEW YORK AND ANTIOCH.

ON AND AFTER SATURDAY, MAY 30, 1874, daily, (Sundays excepted), the Steamer

PARTHENIUS,

CAPTAIN...........................STOWELL

	GOING UP.	GOING DOWN.
San Francisco	Leave 3:30 P. M.	Arrive 10:30 A. M.
Vallejo	Leave about 5:15 P. M.	Leave about 8:45 A. M.
Benicia	Leave about 5:45 P. M.	Leave about 8:15 A. M.
Martinez	Leave ab't 6:00 P. M.	Leave about 8:00 A. M.
N. York Landing	" 7:45 P. M.	Leave about 6:55 A. M.
Antioch	Arrive 8:00 P. M.	Leave about 6:30 A. M.

☞ Excursionists visiting Mount Diablo will find this the most pleasant route by way of MARTINEZ, connecting with BENNET'S LINE OF STAGES.

PHILIP CADUC, 513 Montgomery st.,
je 20 San Francisco.

Miners, whether seeking gold in 1849 or heading on to Virginia City in 1859, traveled by steamboat up the Sacramento River to Sacramento. Everything from mules to frying pans was carried by a continuous loop of shallow draft boats delivering to the jumping-off point of Sacramento. The ships returned with elated or disappointed sourdoughs (miners) clutching or despairing after "seeing the elephant" (the California experience).

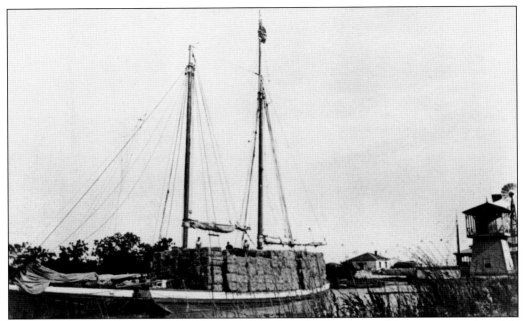

Perhaps the most popular inland sailer was the scow or potato barge. These surprisingly stable shovel-nosed ships stopped along the Contra Costa landings, bringing grain, hay, and potatoes to the wharves at San Francisco. There was a great need for hay, oats, and fodder in a world moved in great part by horses. In 1890, San Francisco had a US census population of 298,997 and an equal, if not greater, number of horses and mules. (CCCH.)

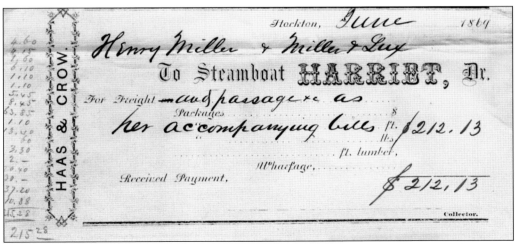

Receipt for goods and passage is acknowledged by this 1869 draft for payment. Haas & Crow were the owners of the *Harriet*, which carried freight and passengers. Capt. J.W. Smith would advertise her sailing and next destination in the local newspaper. Miller & Lux were corporate ranchers in Los Banos and one of the largest landholders in the Unites States in 1860, directly controlling 22,000 square miles of cattle and farmland. (KP.)

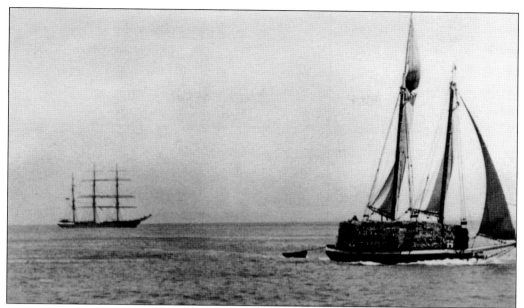

Scows and oceangoing square-rigged ships passed easily along the San Pablo Bay, through the Carquinez Straits, and up the deepwater channel to the landings dotting the Contra Costa shoreline. (ECCHS.)

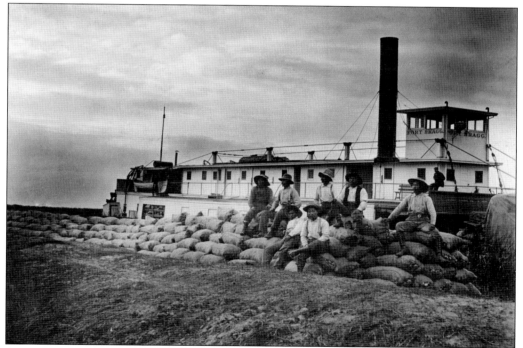

Scow schooners could not sail into the little inlets and canals that soon became the exclusive market for shallow-draft stern-wheelers. The *Fort Bragg* was able to squeeze into Robert's Landing off Indian Slough, which was hidden amongst the man-made islands, sloughs, and swamps to all except experienced tule sailors. (ECCHS.)

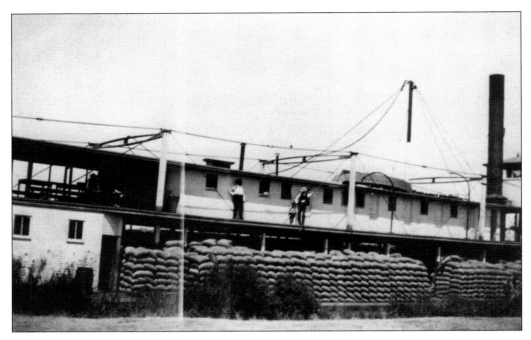

The W.C. *Wright* loads grain at Babbe's Landing off Dutch Slough near Knightsen in 1897. Babbe's Landing was a man-made canal 7 feet deep, 42 feet wide, and 2,838 feet long allowing 100-ton vessels like the steamboat W.C. *Wright* shown here. Heavily burdened ships would wait until the turn of the tide, reverse engines, and back out the half-mile channel into the San Joaquin River. The owner of the landing, Fred Babbe, arrived in California from Prussia in 1850 to search for gold. He, as many hopeful Argonauts, found his fortune in a 300-acre farm. Between 3,000 and 4,000 tons of grain shipped from this landing to the San Francisco markets until its close in 1894. (Above, ECCHS; below, CCCH.)

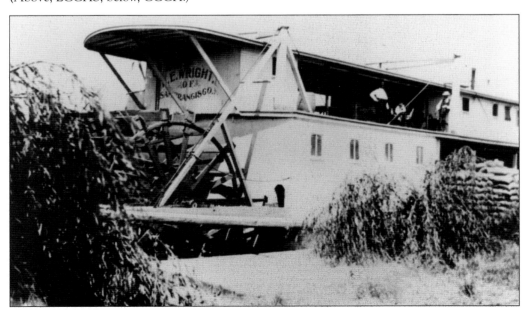

The stern-wheeler *Pioneer* and the barge *Philip* tie up together at the small landing to take on cargo for transshipment to the bay.

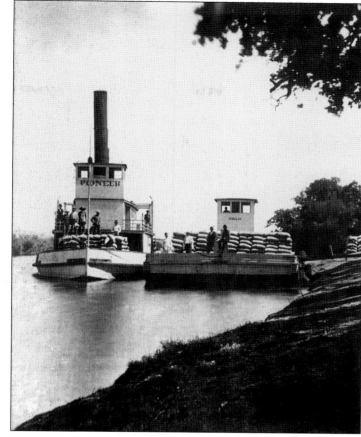

Typical of stern-wheelers from 1850 to 1910, the *Sentinel* carried passengers and product. Note the grain sacks protected on the main deck level. Passengers and staterooms are on the upper deck. (KP.)

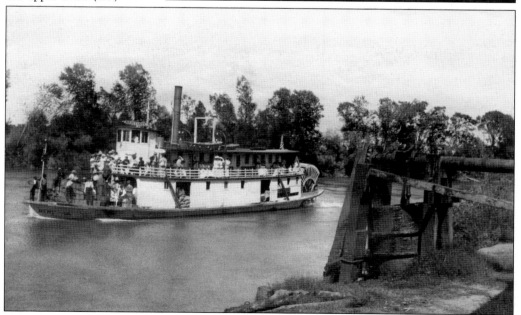

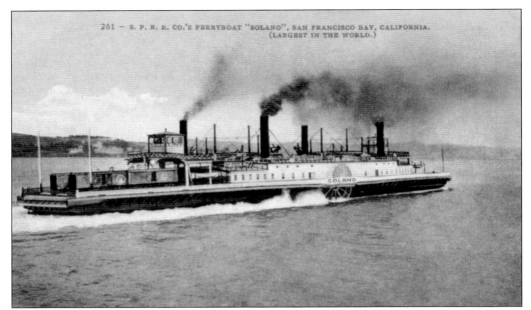

Ferries are for locomotive and train transport, too. The *Solano* was the maritime link that completed the Central Pacific segment of the transcontinental railroad, from Sacramento to San Francisco. The *Solano*, built in 1878, was 424 feet long and 116 feet wide and was capable of carrying entire passenger trains or a 48-car freight train and locomotive. It was in service from 1879 to 1930 between Port Costa and Benicia.

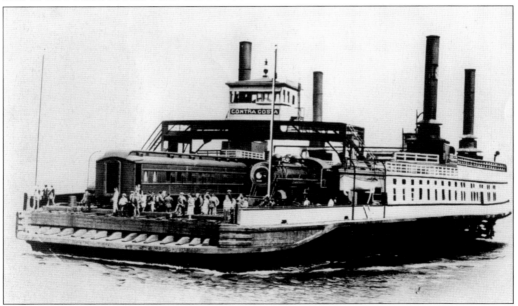

The *Contra Costa*, built in Oakland in 1914, was an even larger ferry than the *Solano* and also carried cars and locomotives until 1930. Both ferries were retired from service in 1930 when the railroad bridge opened, spanning Carquinez Strait for the first time. The *Contra Costa* was scrapped. The *Solano* ended her days as a private harbor breakwater in Antioch, where her skeleton can still be seen today.

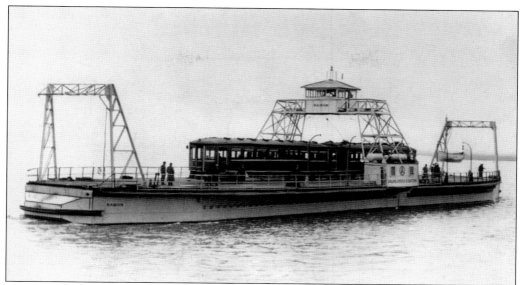

Electric cars run by the Oakland, Antioch & Eastern Railroad competed with the Southern Pacific Railroad for interurban traffic. In 1915, one could board an electric train in Oakland and travel all the way to Chico. At Mallard Island, near Pittsburg, the cars would board the *Ramon* to disembark on land at Chipps Island in Solano County and continue north via Collinsville/Montezuma. (PIT.)

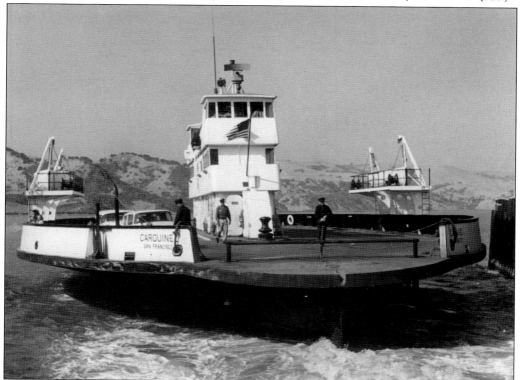

Car Ferries continued operation beyond the bridging of the Carquinez straight. The auto ferry *Carquinez* connected Benicia to San Francisco. (CCCH.)

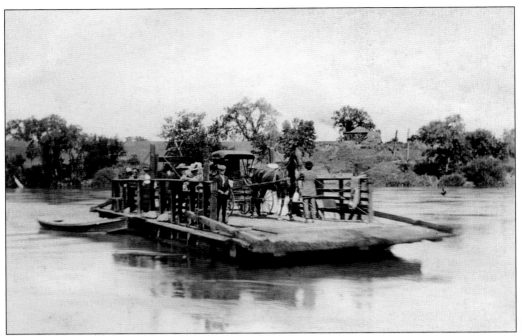

Modest ferry transport between islands was accomplished with cable ferries hauling small barges across narrow sloughs by a horse-powered winch. The cable is affixed to either shore and hangs slack below the water when not in use. (ECCHS.)

The ultimate personal transport is, of course, the lowly rowboat. The far eastern islands in Contra Costa County were inaccessible except by water. The region between Byron and Stockton could not be reached easily except by boat until the Borden Highway, today's State Route 4, was built in 1922 across Victoria Island.

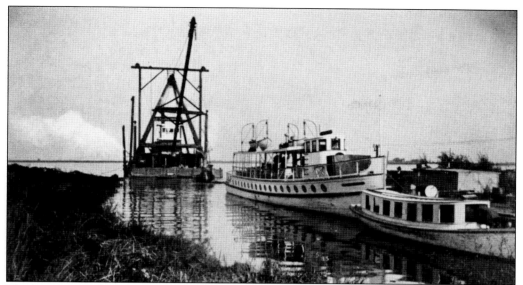

The Lauritzen Fulton Shipyard in Antioch was home to passenger ships *Princess* and *Empress*, grain ships, and to an important levee building and channel-widening dredgers business. (KP.)

Lauritzen had a thriving transport business shipping wheat from East County to Starr Mills in Vallejo and Wheatport. (RV.)

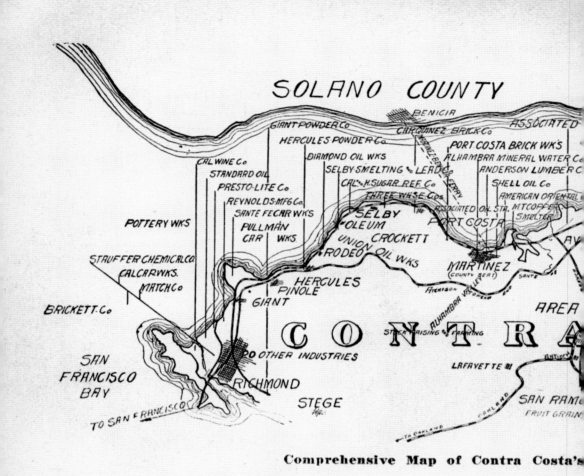

The diversity of Contra Costa's manufacturing and industry is never clearer than when one appreciates the number of different companies along its shore. Each business has a deepwater

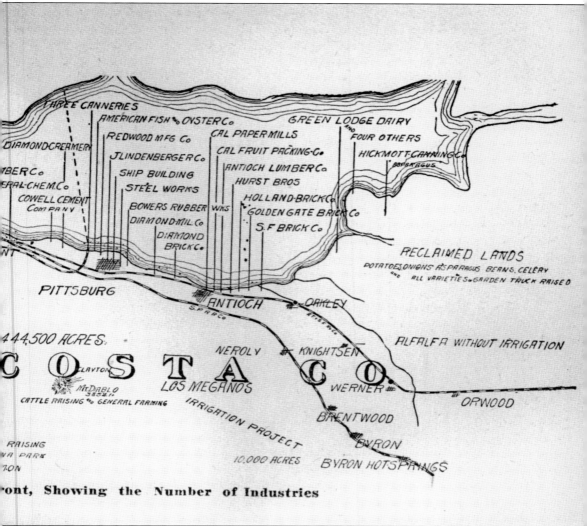

THREE CANNERIES

AMERICAN FISH & OYSTER Co

GREEN LODGE DAIRY

DIAMOND CREAMERY

REDWOOD MFG Co

CAL PAPER MILLS

FOUR OTHERS

...BER Co

J. LINDENBERGER Co

CAL FRUIT PACKING-Co

HICKMOTT CANNING Co

...ERAL-CHEM. Co

SHIP BUILDING

ANTIOCH LUMBER Co

ASPARAGUS

COWELL CEMENT COMPANY

STEEL WORKS

HURST BROS

HOLLAND-BRICK Co

BOWERS RUBBER WKS

GOLDEN GATE BRICK Co

DIAMOND MIL Co

S. F. BRICK Co

DIAMOND BRICK Co

RECLAIMED LANDS

POTATOES, ONIONS, ASPARAGUS, BEANS, CELERY AND ALL VARIETIES & GARDEN TRUCK RAISED

...NT

PITTSBURG

ANTIOCH

OAKLEY

S P R R Co

A T S F R R Co

ALFALFA WITHOUT IRRIGATION

...4,500 ACRES.

NEROLY

KNIGHTSEN

C O S T A C O.

CLAYTON

MT DIABLO 3852 FT

LOS MEGANOS

WERNER

ORWOOD

CATTLE RAISING & GENERAL FARMING

IRRIGATION PROJECT

BRENTWOOD

...RAISING

...VA PARK

...ION

10,000 ACRES

BYRON

BYRON HOTSPRINGS

...ont, Showing the Number of Industries

port. Every agricultural community has a landing along a slough. This liquid highway connects all to San Francisco and the wider world for exports.

31

Travel from the original terminus of the Transcontinental Railroad at Sacramento via steamship down the Sacramento River remained popular even after the railroad line was extended to Oakland. The sister ships *Fort Sutter* and *Capitol City* continued service until 1927, when the *Delta King* and *Queen* replaced them. The fictional Nick and Nora Charles of *Thin Man* movie fame would have taken this route on their way home to San Francisco from New York.

The *Fort Sutter* launched in 1912 from her ways at the Sacramento Bay Shipbuilders yard. She was a four-deck steamer, as was her sister ship, the *Capitol City*, launched just two years prior. She featured a dining room with a capacity of 70, a large social hall, an observation room, a barbershop, a newsstand, a candy store, a barroom/card room, smoking rooms, and washstands with hot and cold water in each of the staterooms.

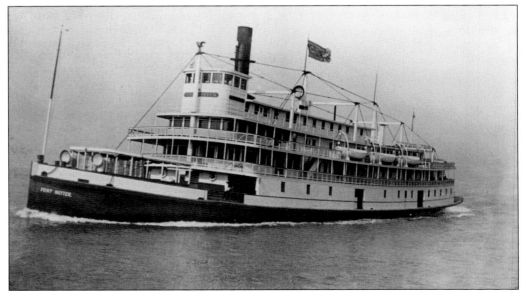

The two ships left their respective ports at 6:30 and passed each other on the 12-hour cruise between San Francisco and Sacramento. They each cost approximately $250,000 to build and held 260 passengers, with 66 staterooms and suites. Each was equipped with bathrooms, hot and cold water, and electric lights. (KP.)

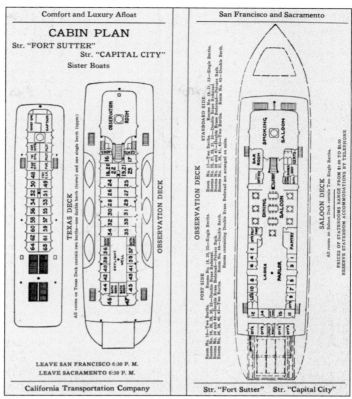

The *Fort Sutter* served the US Navy during World War II as a sailor's billet at Mare Island. She was purchased at the end of the war and returned to Sacramento, where she was planned as a restaurant and fishing club. She ended ignominiously, as so many floating palaces did at Hunter's Point, San Francisco Bay, when she burned in 1959.

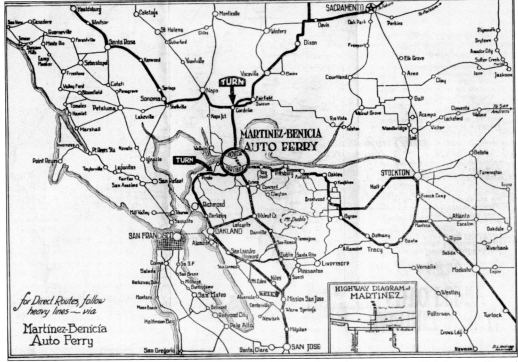

The immensely popular commuter ferry connecting interurban electric cars and highways allowed the romance of water transport to continue into the early 1950s. This Martinez-Benicia promotional map illustrates the number of improved roads and highways that connected the greater Bay Area. Water transport was tertiary behind railroads and automobiles as a preferred method of traveling for business, pleasure, or commerce.

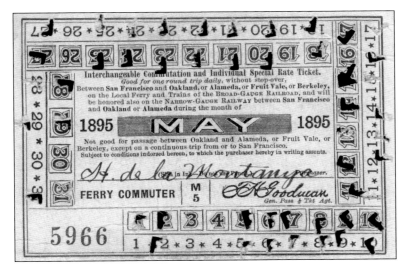

This commutation ticket from May 1885 allowed the holder to live in the growing suburban communities in East Bay towns like Fruitvale, Alameda, and Hayward's yet work in San Francisco. (KP.)

34

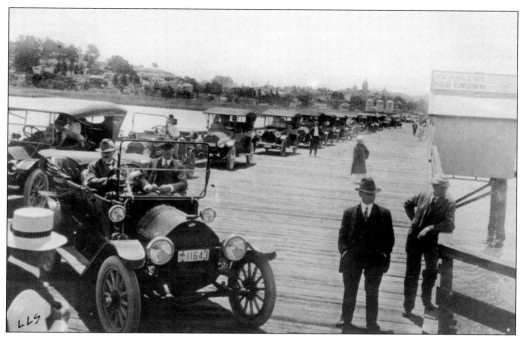

Prosperity in the 1920s brought a Ford motorcar within reach of nearly every family in Contra Costa County. Here, the lineup for the ferry begins. (CCCH.)

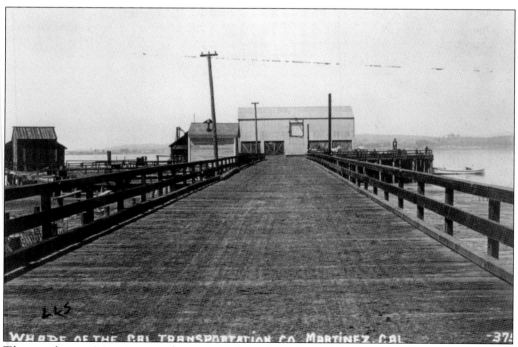

The mole at Martinez, where one boarded the Martinez to Benicia ferry, is shown here. (CCCH.)

The Richmond Mole provided ferry transport to San Rafael, Vallejo, and San Francisco. The Richmond and San Rafael Bridge has not yet halted ferry service as of this May 1956 image. (PH.)

Martinez-Benicia Auto Ferry

TIME TABLE

Lv. Benicia		Lv. Martinez	
6:40	2:40	7:00	3:00
7:20	3:00	7:40	3:20
8:00	3:20	8:20	3:40
8:20	3:40	8:40	4:00
8:40	4:00	9:00	4:20
9:00	4:20	9:20	4:40
9:20	4:40	9:40	5:00
9:40	5:00	10:00	5:20
10:00	5:20	10:20	5:40
10:20	5:40	10:40	6:00
10:40	6:00	11:00	6:20
11:00	6:20	11:20	6:40
11:20	6:40	11:40	7:00
11:40	7:00	12:00	7:20
12:00	7:20	12:20	7:40
12:20	7:40	12:40	8:00
12:40	8:00	1:00	8:20
1:00	8:40	1:20	9:00
1:20	9:20	1:40	9:40
1:40	10:00	2:00	10:20
2:00	10:40	2:20	11:00
2:20		2:40	

Light figures denote A. M.
Dark figures denote P. M.

Extra Boat when traffic warrants

LUNCH ROOM, CANDIES AND COLD DRINKS ON ALL BOATS

Reduced Rates

Automobile, one way55c
Passenger, one way10c
Children (5 to 12)05c

BUY ROUND TRIP TICKETS AND
SAVE MONEY, TIME, ENERGY

Ferry transport from Martinez to Benicia for 50¢ seems a bargain. Competition with the bridges forced Southern Pacific to reduce the one-way fare even more to a low of 40¢ ($3.40 in 2012 buying power). The fare reduction was not successful in luring commuters back to the ferry, and the service was discontinued in 1956.

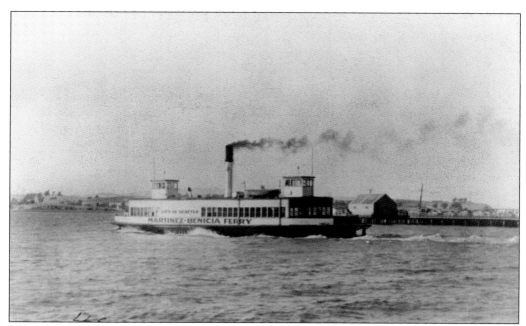

The *City of Seattle* was built in 1888. She was the first ferry in service in Puget Sound. She was sold and began the Martinez-Benicia Ferry route in 1913. She served as USN *YFB54* for the Navy during World War II and after as the rechristened *Magdalena*. Unlike most ferries, she did not die on the scrap heap or in flames. Her upper story lives on as a Sausalito houseboat.

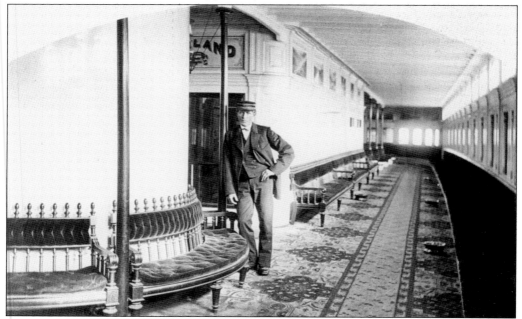

The Southern Pacific Ferries crossing the bay were beautifully appointed ships with mahogany trim, stained-glass fittings, horsehair-stuffed and red velvet upholstered cushions, and oriental rug floor coverings. This conductor poses with casual pride in his vessel. Every effort was to ensure deck safety. Note a cuspidor placed every 10 feet for the convenience of men passengers.

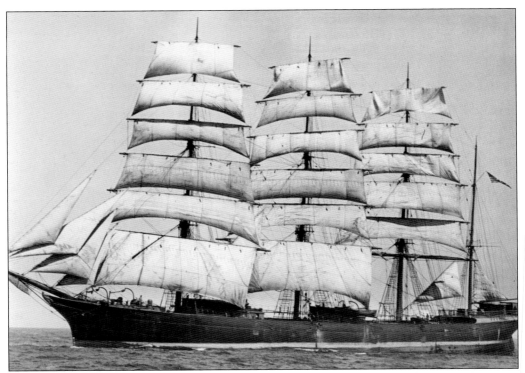

The very last merchant clipper ship to leave San Francisco Bay sails from Port Costa with a grain cargo bound for Liverpool, England. Builder John Reid & Co of Glasgow launched the *Kenilworth* (2,290 tons) in 1887. This fine British merchant ship burned at Port Costa, but was salvaged and reborn as an American flagship, the *Star of Scotland*, at the Union Iron Works in San Francisco. She had a long career and ended her days in the South Atlantic when she was torpedoed and sunk by a German submarine in World War II. (NPS.)

Clipper ships were often sailed onto mudflats and abandoned along the Contra Costa shore. A ghost fleet from the sailing age cannot compete with cheap coal, oil fuel, and the demands of product delivery on time and on schedule. Hulls found their last duty as bumper guards, hunting lodges, restaurants, and yacht clubs. (LOC.)

Three

FISHING AND TIMBER

Both fishing and harvesting timber rely heavily on waterways. Fishing is farming below the surface of seas and rivers. After loggers felled redwood trees and transported them to the shore, the trees were often floated on the surface of seas and rivers. Maritime Contra Costa combined both industries with large operations. The Fisherman's Wharf operation extended from Pier 90 in San Francisco to the F.E. Booth Canning Company in Pittsburg. So, too, did the redwood lumber trade. The largest redwood lumber manufacturing yard in the world was not in Sonoma, Mendocino, or Humboldt County, but was along the Contra Costa shore in Pittsburg. Redwood was rafted from Sonoma County down Richardson Bay to Redwood Manufacturing Company. Alternatively, lumber ships took redwood cargo from the Northern California coast and sailed for Contra Costa. In the late 1800s, both major fishing operations and milling of the prized redwood lumber distinguished Pittsburg, known today for its history as a steel-manufacturing town.

Commercial fishing and canning of fish from the Sacramento and San Joaquin Rivers continued until 1934, when it was halted by the State of California due to diminishing delta fish populations. Some local anglers turned into sport-fishing guides to earn their livelihoods. Many more seasonally fished from the North Coast to Alaska as members of the San Francisco–based Alaska Packers Association. Others moved to Monterey to establish the world-famous Cannery Row sardine fishing and packing trade.

Fishing was not limited to salmon, bass, smelt, and herring. Chinese immigrants established shrimp camps and drying sheds along the Point Richmond shoreline. Shrimp were netted, dried, and exported to China for consumption. The last San Francisco Bay example of this once common practice is at China Camp State Park near San Rafael in Marin County.

Point Richmond was the "Nantucket of the West" at the end of the whaling industry. Nantucket, Massachusetts, as immortalized in Herman Melville's novel *Moby Dick*, focused on the Atlantic sperm whale. The whaling ships in the Pacific hunted primarily baleen whales, such as the humpback and western gray whales. The last whale-processing station in the United States closed in 1976, at Point Richmond, where whale meat was being processed and used as fertilizer.

Italian fishermen using small seines introduced commercial shrimp fishing to the San Francisco Bay in 1869. The industry changed dramatically when the Chinese entered the picture two years later with nets of a new design. These controversial nets were able to snare large quantities of shrimp and small fish. The shrimp were dried and exported to China. The marginal lands shown here are located at Point Richmond. State and local fishing interests battled with the Chinese shrimp interests until 1911, when the Chinese nets were banned entirely. (RICH.)

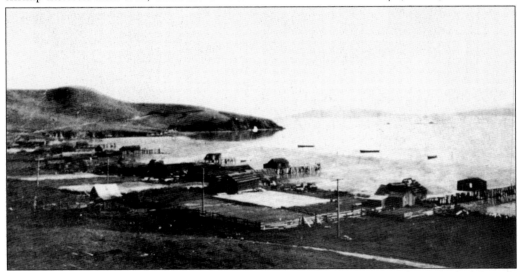

The Chinese shrimp fishermen organized their operations in several ways. Some worked directly for Frank Spengler or the Quan brothers; other boats worked on a shares basis. Many sold their catch directly to San Francisco Chinatown shrimp brokers who bought and sold shrimp just as any other food commodity caught and processed along the shoreline. Chinese shrimp companies maintained offices in San Francisco, including the Golden Gate Shrimp Company, Quong Duck Chong Company, and the Wing Hee Wo Shrimp Company—each using over 50 nets per boat. (RICH.)

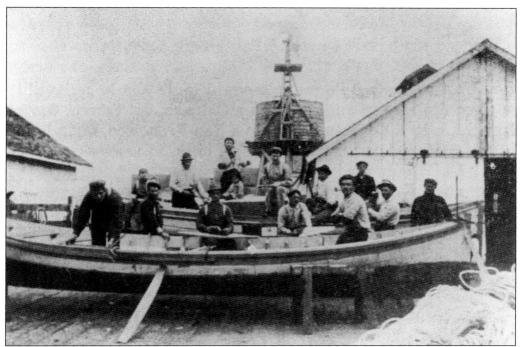

Commercial fishing in San Francisco Bay is really the story of Italian communities and their introduction of the Mediterranean fishing boats used in Italy for centuries. In Contra Costa, fishermen improved on the silenas (known locally as feluccas), which were open boats with a deck, and also on the Monterey motorized fishing boat that is associated with Monterey's Cannery Row but was first made in Pittsburg. (NPS.)

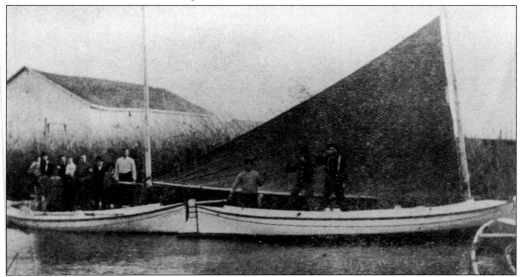

These rigged catboats are shallow draft, beamy, and stable. They are easily handled, whether fishing with gill nets for herring or crab nets for local Dungeness crab. These wonderful craft were the staple bay and inland fishing boats until the introduction of the modern motorized Monterey Clipper fishing boat in 1925. (NPS.)

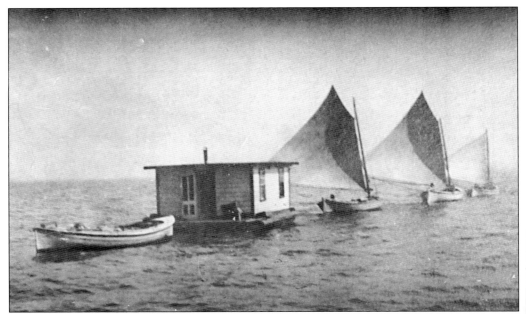

This fishing crew set out from San Pablo Bay or Hurricane Bay for a week of fishing with its combination bunk and cook house in tow. These three feluccas, two with their gaff-rigged sails trimmed, are heading up the Sacramento River for some salmon fishing. (PIT.)

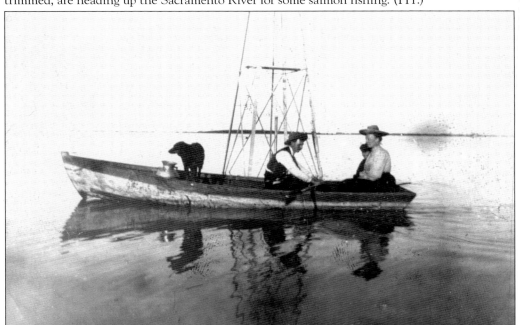

Farmers used simple rowboats for transport and commerce. Mail service to towns along the Sacramento–San Joaquin delta was commonly carried by water transport up until the late 1950s. Jersey Island was an important destination. All trolley horses in San Francisco went to this island farm regularly to heal and sooth their aching hooves from months of hard cobblestone toil on the streets of San Francisco. (ECCHS.)

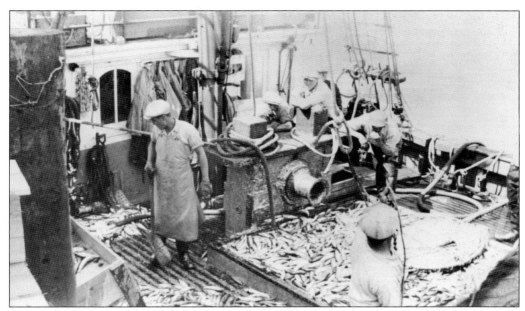

Herring is the last commercial fishing business in the San Francisco Bay as of 2013. The bay fish stocks for halibut, sturgeon, salmon, and sardines no longer support commercial harvesting; clams, oysters, and Dungeness crab harvests took place outside the Golden Gate. The California Fish and Game Commission monitors the industry closely to ensure its future. Even the herring season was closed in 2009 to ensure the future population in the bay. (PIT.)

Many commercial fishermen in Pittsburg became sports-fishing guides and party-boat guides when commercial net fishing in the Sacramento and San Joaquin Rivers ended in 1958 due to diminishing fish stocks. Silt and mercury washing down from 19th-century placer and hydraulic mining had finally taken its toll. Commercial operators followed the fish and established operations in Monterey, where sardines were commercially fished and canned. (PIT.)

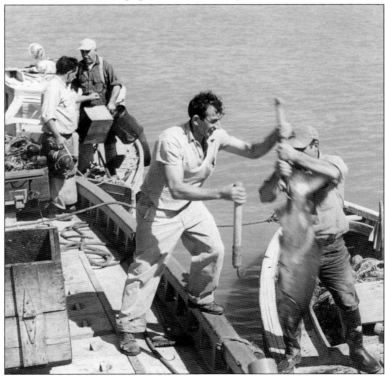

43

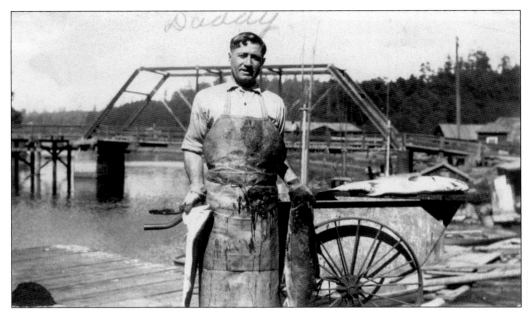

Many fishermen followed seasonal commercial fishing along the northwest coast and into Alaska. This man poses as he cleans his catch in Fort Bragg or Eureka. The photograph sent back home remembers daddy to his children. Fathers could be away while commercially fishing for four months of the year. (PIT.)

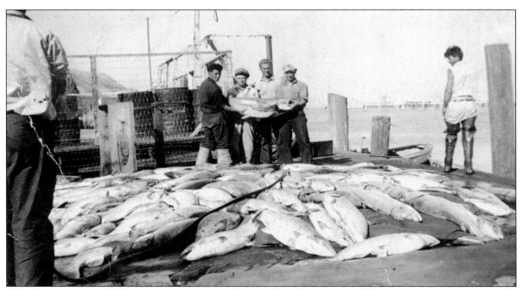

The bounty of wild king salmon swimming up the Sacramento River to spawn supported a commercial industry along the river beginning as early as 1869. Fish that are smoked or cured do not require refrigeration, but the shelf life is short if the fish is not kept cool. This means such fish are perfect for limited, local California sale, but not for export. (PIT.)

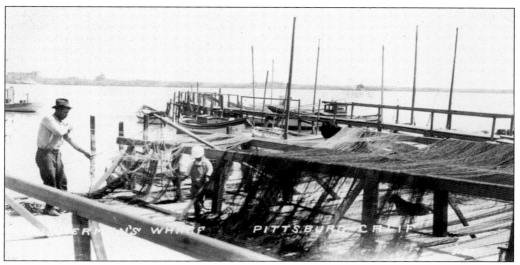

Huge salmon runs brought commercial gill net fishing up the San Francisco Bay estuary into Contra Costa County. Italian fishermen followed the fish in schools the size of which one can only dream about today. Commercial fishing operations netted 10 million pounds of salmon in one year in the Sacramento River in the early 1880s. By 1884, the first of many cyclical fish populations collapsed, crippling the industry. (PIT.)

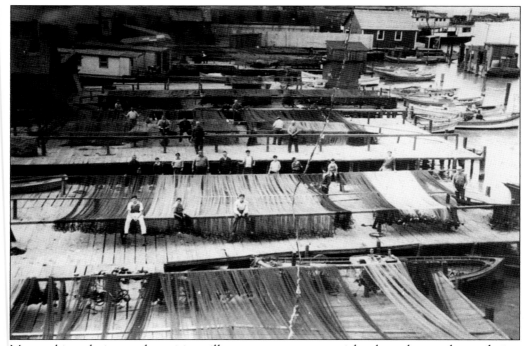

Men making, drying, and repairing gill nets were a common sight along the marshes and piers lining the wharves from Martinez to Pittsburg from 1870 to 1930. The water was so clear one could see the bottom. Old-timers claimed fish populations during the fall king salmon run were so vast that one could walk from Antioch to Collinsville and never wet his feet. (PIT.)

45

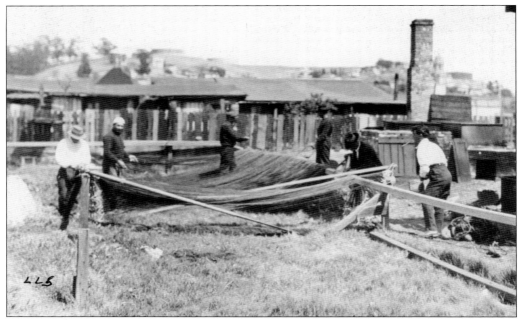

Spongy marshland reached as much as a quarter mile from shore all along the Contra Costa shore. This area, unsuitable for agriculture or permanent housing, provided acres of transition land for clamming, small game trapping, crawdadding, and equipment preparation. Eventually, this marshland was dredged, filled in, or diked to create a commercially usable shoreline. (CCCH.)

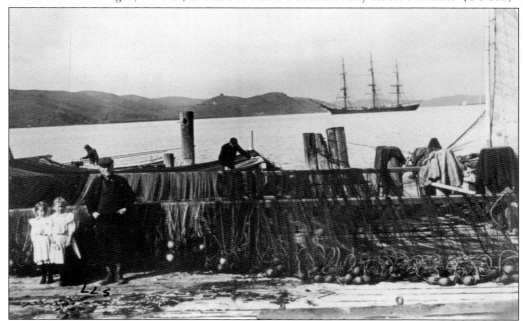

Oceangoing square-rigged ships sailing to Antioch were a common sight. Mooring fees were lower the farther east one sailed. Ship captains waiting for cargo or delayed by weather would often moor their vessels for extended periods in the fresh San Joaquin River to destroy saltwater barnacles and wood-boring threats to their hulls. (PIT.)

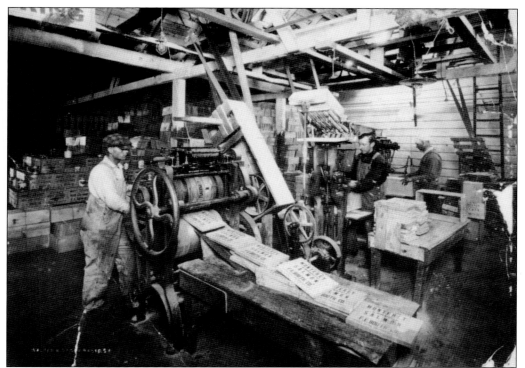

The F.E. Booth fish-canning operation was active in both Monterey and Pittsburg. Sardines, anchovies, and squid were caught and processed in Monterey. Salmon, caught in the Pacific Ocean, were processed and canned in Pittsburg. This Black Diamond (Pittsburg) plant employed 400 people in 1910. The canning operations in Pittsburg were the standard for local canning for 50 years. (PIT.)

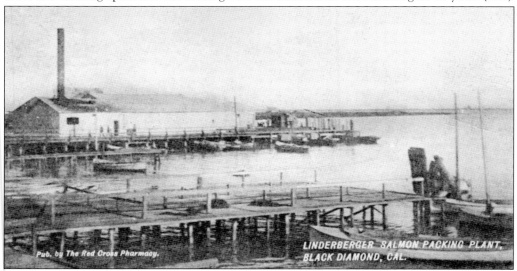

The Lindberg canning plant at Black Diamond, today's Pittsburg, processed and canned salmon caught in the river and the sea. Black Diamond was the canning center of California between 1880 and 1920. The tall smokestack emerging from the plant's roof is from the boiler required to generate sufficient steam to cook and sterilize the fish once cut, packed, and soldered into tin cans. (KP.)

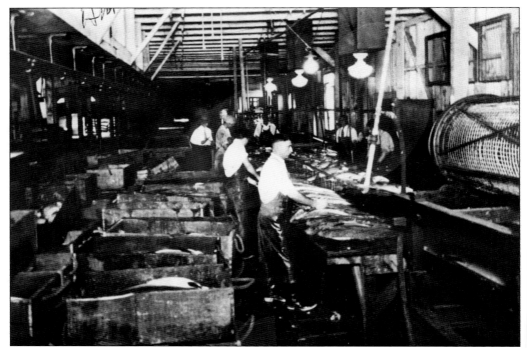

Before mechanization, the cutting and cleaning of fish was accomplished by hand. This work was done primarily by Chinese workers until the Chinese Exclusion Act of 1882. These processing plants were conveniently located over the river for access to fish and for convenient waste disposal. The fish waste and by-products just went through the floorboards. The tide, catfish, bream, crawdads, and shrimp did the cleanup. (PIT.)

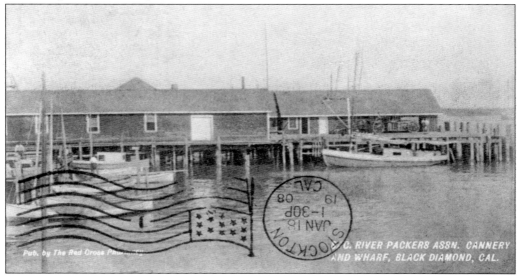

The S&C River Packers Association was a cooperative canning operation of independent fishing boats. Other canners along the river included Paladine Fish Company, King Morse Canning, Black Diamond Canning, Pioneer Canning Company, Sacramento River Packers, and San Joaquin Fish Company. Real-photo postcards such as this reflect local pride in city industries. (KP.)

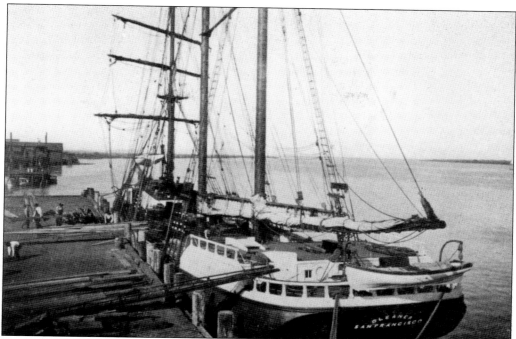

Timber cut along the Sonoma and Humboldt Counties coastline was not necessarily milled at those locations. Often, the geography only allowed booming of giant trees onto lumber ships through an elaborate system of ropes and cranes. Timber, particularly redwood trees, was sailed down the coast for milling in Contra Costa. (PIT.)

As the number of salmon found in the delta declined, commercial fishermen followed the fish to Monterey and up the California, Oregon, and Washington coasts, farther and farther from home. The salmon schools in Alaska were so abundant that one three-month fishing season could support a Contra Costa fisherman and his family for an entire year. The Alaska Packers Association, located on California Street in San Francisco, is another example of a city office for a Contra Costa fishing and canning operation.

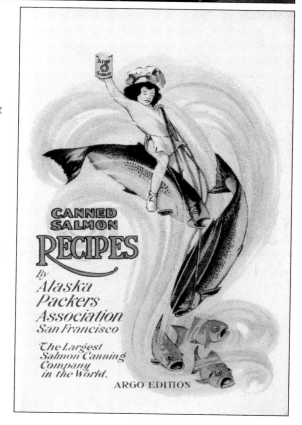

CANNED SALMON RECIPES By Alaska Packers Association San Francisco

The Largest Salmon Canning Company in the World.

ARGO EDITION

Fishing operations included hunting for whales. The Pacific whaling fleet hunted baleen whales in the 19th century. Demand for whale oil for lighting and whalebone (baleen) for women's corsets ended with the Edison electric light and less-constraining women's fashions. Whaling began once more after World War I, with faster ships and harpoons propelled by cannons. Ships searched for sperm, humpback, fin, and sei whales. (RICH.)

The Del Monte Fishing Company (1956–1971) and the Golden Gate Fishing Company (1958–1965) operated out of Point Richmond until Congress passed the Marine Mammal Protection Act of 1972. They were both whaling companies. (CCCH.)

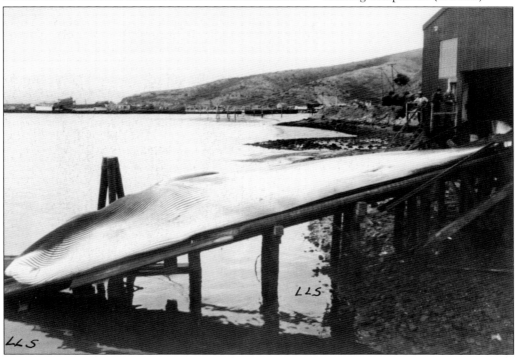

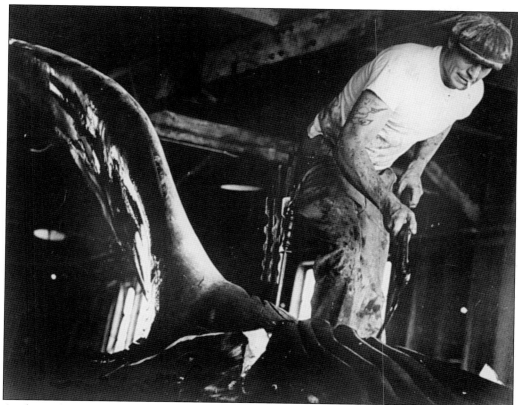

At the end of the commercial harvesting of whales in the Pacific, whale meat was used for cat and dog food and as a fish emulsion fertilizer. Sperm whale oil (spermaceti) is particularly fine oil and was formerly used as a lubricant in high-temperature nuclear reactors. (RICH.)

Schoolchildren still went on field trips in 1960 to see how food processing and manufacturing plants functioned and to investigate potential employment choices. No future employment was to be found here. These boys seem to take a fiendish delight in abusing this dead baby whale. (RICH.)

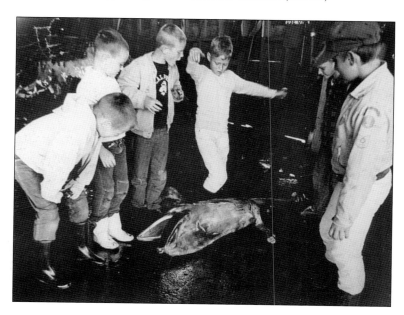

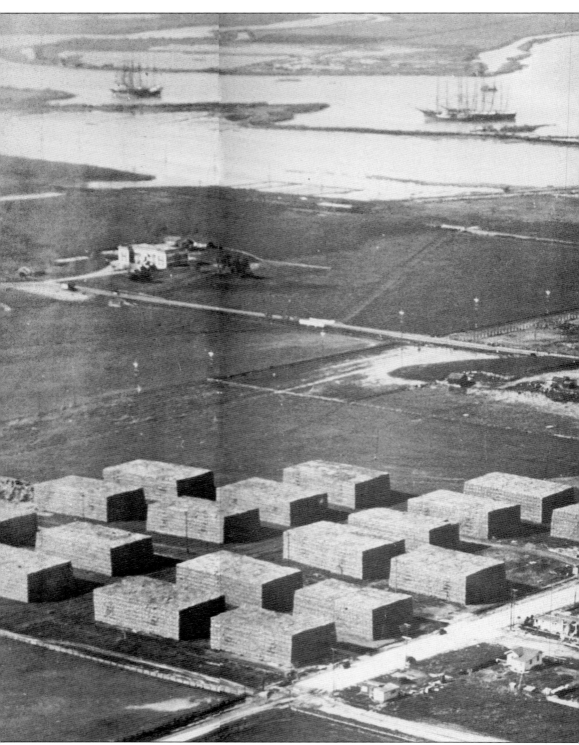

The Redwood Manufacturing yard, as seen from the air in this composite image, shows the

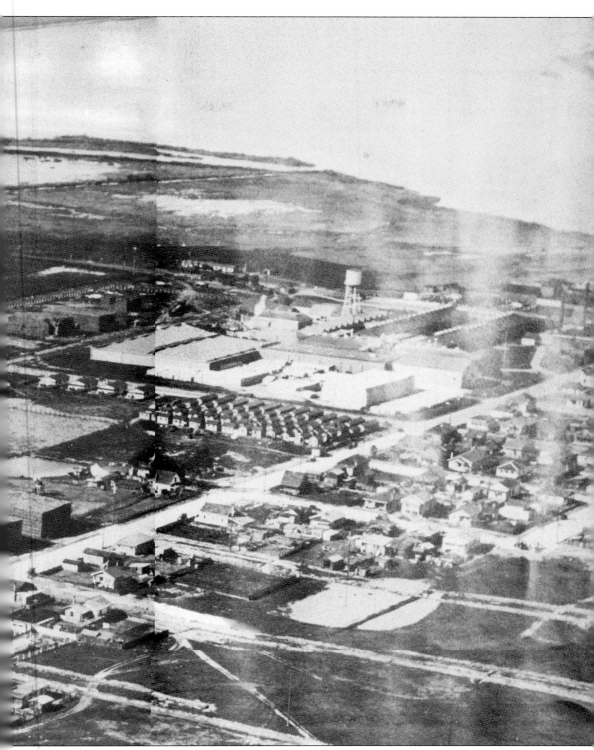

vastness of its operation. It reaches from Bay Point to Black Diamond. (AH.)

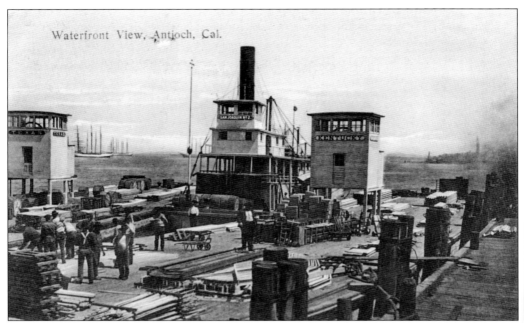

Finished pine, cedar, and fir lumber is loaded on board three intercostal ships at Beebe Lumber, Antioch, in 1908 for transport upstream. The Beebe Lumber Company, heir to the Rouse, Forman & Beede Lumber Company, is the oldest lumber concern in California. Ships such as the *Texas*, *San Joaquin*, and *Kentucky* moved finished goods up river, turned about, and collected raw material for the return journey. (KP.)

The Redwood Manufacturers Company (REMCO) plant and yard was located in Pittsburg adjacent to the U.S. Steel Corporation. The company produced a wide array of redwood products—such as pipes, tanks, doors, balusters, posts, shingles, siding, railing, columns, and staves. A featured use of redwood was shaping of staves into water pipes—a long-lasting solution before iron and concrete alternatives.

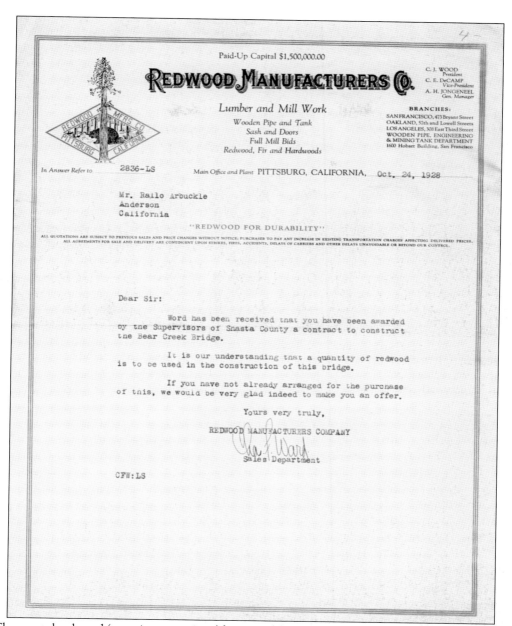

REDWOOD MANUFACTURERS CO.

C. J. WOOD
President
C. E. DeCAMP
Vice-President
A. H. JONGENEEL
Gen. Manager

Lumber and Mill Work

Wooden Pipe and Tank
Sash and Doors
Full Mill Bids
Redwood, Fir and Hardwoods

BRANCHES:
SAN FRANCISCO, 473 Bryant Street
OAKLAND, 57th and Lowell Streets
LOS ANGELES, 308 East Third Street
WOODEN PIPE, ENGINEERING
& MINING TANK DEPARTMENT
1600 Hobart Building, San Francisco

In Answer Refer to 2836-LS Main Office and Plant PITTSBURG, CALIFORNIA, Oct. 24, 1928

Mr. Railo Arbuckle
Anderson
California

"REDWOOD FOR DURABILITY"

ALL QUOTATIONS ARE SUBJECT TO PREVIOUS SALES AND PRICE CHANGES WITHOUT NOTICE; PURCHASER TO PAY ANY INCREASE IN EXISTING TRANSPORTATION CHARGES AFFECTING DELIVERED PRICES. ALL AGREEMENTS FOR SALE AND DELIVERY ARE CONTINGENT UPON STRIKES, FIRES, ACCIDENTS, DELAYS OF CARRIERS AND OTHER DELAYS UNAVOIDABLE OR BEYOND OUR CONTROL.

Dear Sir:

Word has been received that you have been awarded by the Supervisors of Shasta County a contract to construct the Bear Creek Bridge.

It is our understanding that a quantity of redwood is to be used in the construction of this bridge.

If you have not already arranged for the purchase of this, we would be very glad indeed to make you an offer.

Yours very truly,

REDWOOD MANUFACTURERS COMPANY

Sales Department

CFW:LS

The coastal redwood (*sequoia sempervirens*) harvested from coastal southern Oregon to Monterey County, California, was the superior and preferred building material of the 19th century. Numerous small lumber manufacturing business preprocessed timber and boomed it onto ships for transportation to the Redwood Manufacturers Company yards in Pittsburg. Logs from Sonoma, Marin, and Humboldt Counties were trained to Petaluma and upper San Pablo Bay for booming/rafting to the Contra Costa Plant. Here, the raw wood material was cut, lathed, and turned into the two-inch-by-four-inch framing material, exterior siding, interior paneling, and other components making Victorian-age San Francisco so architecturally appealing. It was the fire-resistant quality of redwood exterior sheathing and framing that helped limit destruction during the Great San Francisco Earthquake and Fire of 1906.

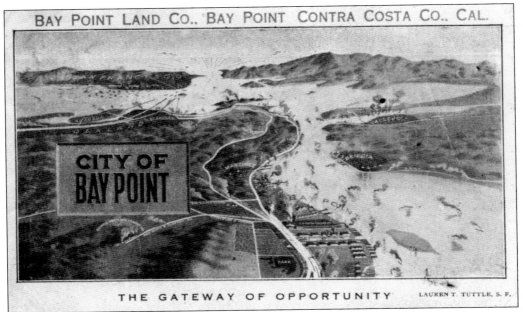

This bird's-eye-view promotional advertisement for the Bay Point Land Company is not very exaggerated. It emphasizes the 70 miles of deepwater access, the ship traffic, and the manufacturing dotting the entire Contra Costa shoreline. Bay Point would reinvent itself as West Pittsburg, the industrial city, emphasizing steel industry jobs. It returned to the original name, Bay Point, in 1993 to remarket itself as a residential community during the late-20th-century housing boom. (KP.)

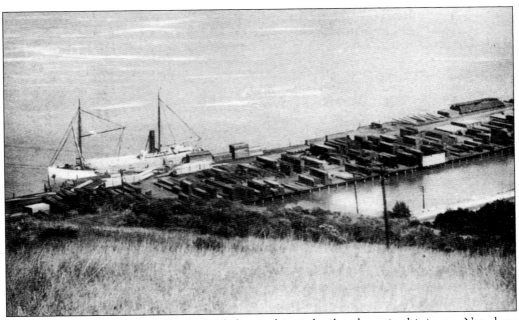

Finished lumber materials wait to be loaded onto ship and railroad cars in this image. Note how the spongy marshland is dredged away to create a tall levee, making a man-made deepwater shoreline dock. (KP.)

Four

FARMING AND PACKING

Farming in California has always meant agribusiness; Contra Costa's agricultural history is not one of subsistence farming on a few acres. Most Spanish (1784–1810) and Mexican (1819–1846) land grants in Contra Costa County had water access and a river or creekside landing for shipping produce to market. Hand-drawn maps, or *diseños*, of these ranchos depict properties containing anywhere from 3,000 to 20,500 acres.

Cattle ranching and the sale of cattle hides to eastern United States leather manufacturers was one of the first cash crop businesses of Contra Costa. Introduction of domestic wheat and oat seed is often attributed to Dr. John Marsh, who owned Rancho los Meganos. Wheat cultivation is a dry-farming crop that does not require irrigation, making the hills and dry plains of Contra Costa County and the upper San Joaquin Valley ideal growing areas. More grain products were shipped from this agricultural region between 1870 and 1900 than from all other areas in the United States combined. Much of the grain was transported from the McNear Wharf and the California Wharf and Warehouse companies (Balfour Guthrie & Co.) located at Port Costa.

Fruit, nut, and vegetable production were introduced as irrigation canals redirected water from creeks and sloughs. The federal Swampland Reclamation Act of 1860 allowed creation of land from wetlands in the eastern end of the county, adding to the amount of land suitable for growing celery, tomatoes, lettuce, corn, and asparagus. Russet potatoes, for which Idaho and Luther Burbank are justly famous, were grown early on in these reclaimed land tracts.

Preserving seasonal and large-production commodities—including peaches, apricots, cherries, tomatoes, pears, and asparagus—was accomplished through heat-process canning in metal containers. Even with refrigerated (ice) railroad cars, it was difficult to transport fresh seasonal fruit and vegetables across the Great Basin to the East, but air-dried or sulfur-dried fruits could make the journey. The largest fruit-drying operation in California was located in Oakley. Freeze-dry food processing became an alternative in the 1970s. Growers' cooperatives (Grange) and fruit exchanges marketed and shipped local produce. Canneries such as Hickmott Foods, Western California Canners (later known as Tillie Lewis Foods), and F.E. Booth (fish) Canning Company were large employers.

Parallel to the rise of manufacturing along the San Pablo Bay shore were the agricultural successes in East County. The grain fields were so vast that harvesting teams would often reap to the west for a whole day and reap in to the east the next. Tonnage yield per acre was not great compared to 21st-century standards, but the amount of acreage under production was immense.

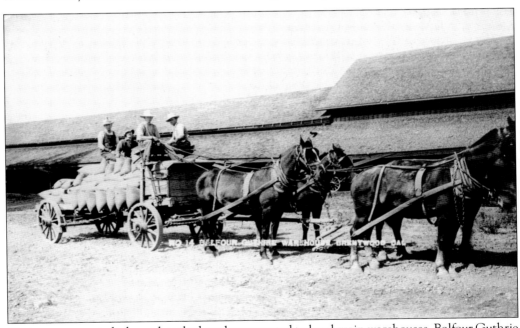

Grain was separated, cleaned, sacked, and transported to local grain warehouses. Balfour Guthrie & Co. was the largest grain exporter in the West, shipping most California grain to Britain and the European continent. It built grain warehouses at every train depot from Tulare to Brentwood to aggregate product.

George W. McNear (1838–1909), the "Grain King of California," was a major San Francisco businessman who shipped agricultural products directly from Port Costa. Originally from Maine, McNear owned ships, banks, flour mills, brick manufacturing plants, wharves, and warehouses throughout Contra Costa County. His wharf at Port Costa was large enough to load 10 deepwater vessels at a time. (CHS.)

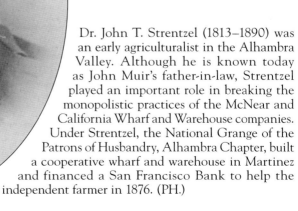

Dr. John T. Strentzel (1813–1890) was an early agriculturalist in the Alhambra Valley. Although he is known today as John Muir's father-in-law, Strentzel played an important role in breaking the monopolistic practices of the McNear and California Wharf and Warehouse companies. Under Strentzel, the National Grange of the Patrons of Husbandry, Alhambra Chapter, built a cooperative wharf and warehouse in Martinez and financed a San Francisco Bank to help the independent farmer in 1876. (PH.)

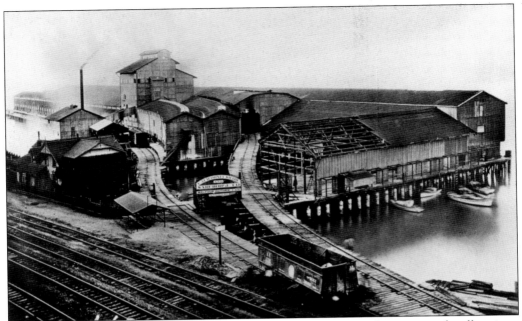

The California Wharf and Warehouse Company in Port Costa was the terminus for all grain—wheat, barley, and oats—shipped along the San Pablo and Tulare Railroad. The huge grain-growing areas of the upper San Joaquin were landlocked. The rail line was specifically built to bring that grain to the world market. The Balfour & Guthrie Co. built grain warehouses all along the line as new towns were created and the rail line was built.

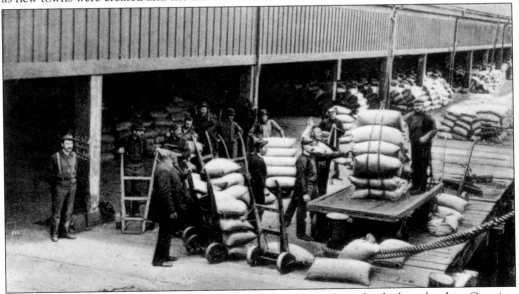

Grain and produce were manhandled by hand dolly and hoist from the dock to the ship. Creating deepwater landings in Contra Costa eliminated the need to transship product to the Port of San Francisco just to reload to oceangoing vessels. The Port of San Francisco still claimed a duty or tax on shipments made through the Golden Gate regardless of embarkation dock. The tricky part was collecting that tax.

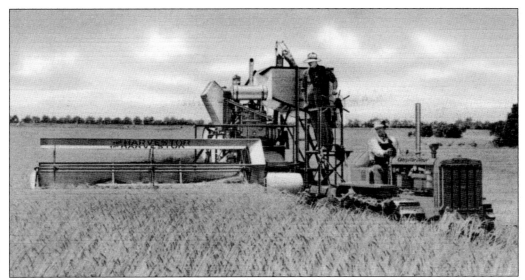

The caterpillar tractor is an invention directly associated with the soft, peat-land farms of eastern Contra Costa County. The land will not support heavy farm equipment mounted on narrow-track wheels. The solution is wide-track continuous ribbon traction. First developed prior to World War I, these track crawlers would make a difference in moving artillery in the mud and helping to win the war in Europe.

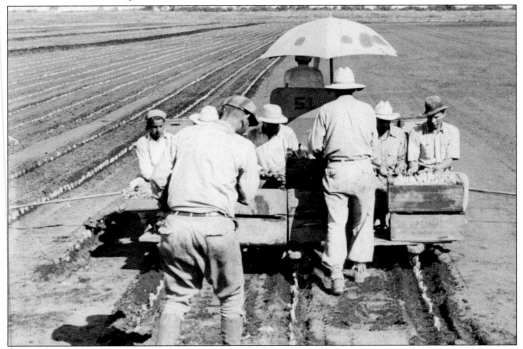

The soft peat islands are made by ringing an area with a berm or levee and pumping the water from the land into the slough. These wetlands are perfect for growing asparagus. This perennial plant is actually a fern. Once planted, it will yield for years without needing to be replanted. Asparagus can be eaten fresh, pickled, or canned. (RV.)

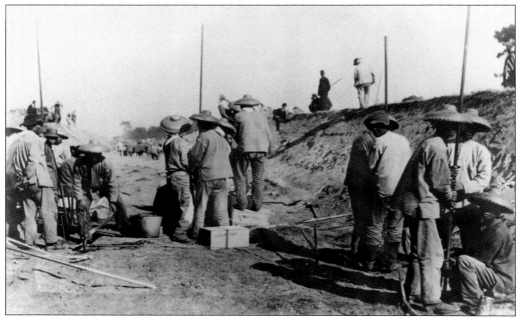

The key to successful fruit and vegetable production is water control: not too little and not too much. Chinese laborers released from railroad construction were hired to build levees to keep water out, thereby creating land where wetlands once existed. Land created from the wetlands was peat soil and rich river bottomland. The secret to farming these lands was to keep the berm, levee, or dike from breaching. (AH.)

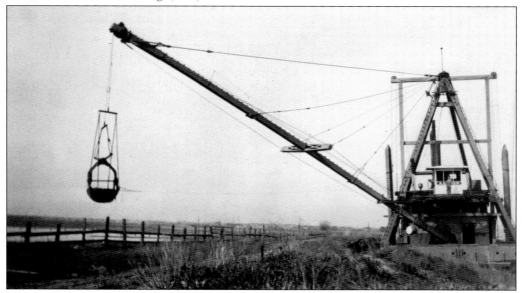

Chinese laborers were displaced by mechanized levee-building using huge clamshell dredgers mounted on shallow draft ships such as the *Albion*. Portuguese immigrants from the Azores islands cornered a near monopoly on this business, one bucket of mud and rip rock at a time. The Dutra family from Rio Vista was contracted to deepen the Sacramento channel and improved many man-made islands in the county. (ECCHS.)

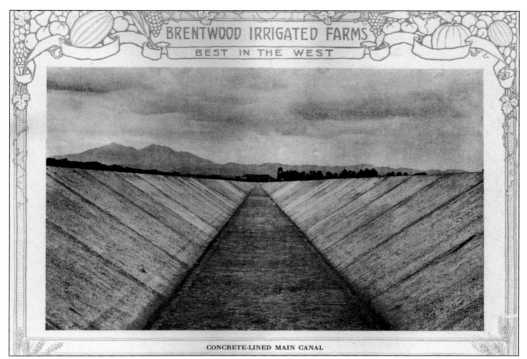

BRENTWOOD IRRIGATED FARMS
BEST IN THE WEST

CONCRETE-LINED MAIN CANAL

Balfour Guthrie & Co. was a leader in moving water into previously dry farming areas, under the auspices of Brentwood Irrigated Farms. They dredged and cemented channels to make a reliable system to deliver water into formerly dry farming fields. Productive 20-acre and 40-acre parcels suitable for specialized high-yield fruit and vegetable farming increased land values. Real estate sales became brisk between World War I and World War II.

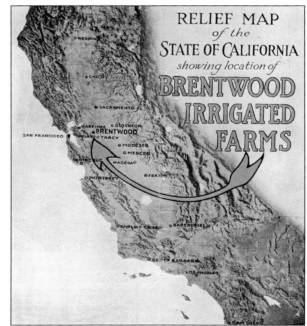

RELIEF MAP
of the
STATE OF CALIFORNIA
showing location of
BRENTWOOD
IRRIGATED
FARMS

The publicity department of Balfour Guthrie & Co., San Francisco, went into overdrive advertising farming land in Brentwood. Entire passenger cars of prospective buyers were trained and brought in from the Midwest in the 1920s. The Bank of Brentwood, again an enterprise financed by Balfour & Guthrie Co., was established to finance land sales.

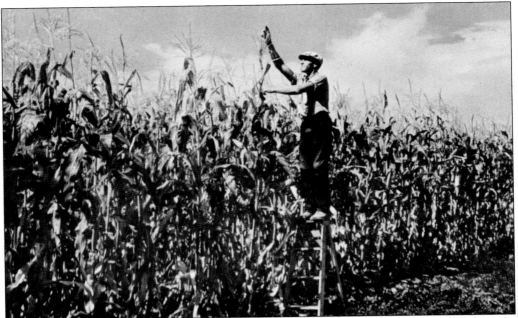

The motto of Brentwood Irrigated Farms was "Best in the West," complete with a local booster club of the same name. Bigger was considered better at the time, and stalks of corn taller than a man could reach were considered a testament to quality. Modern agricultural science has now shorted the stalks and increased the number of ears.

Celery was a favorite crop to grow on reclaimed swampland islands. Celery requires quantities of freshwater delivered naturally when the crop is grown inches, and often feet, below river level. If additional water is needed, the pumps that normally pump water out from the island and into the river could be reversed. Celery was a major crop until water salinity levels grew too high in the 1960s. (RV.)

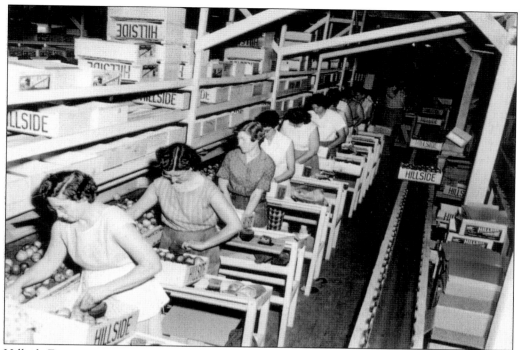

Hillside Farms was yet another offspring of the British firm Balfour Guthrie & Co. headquartered in San Francisco. This fresh fruit-packing shed packed apricots in 20-pound boxes for ice railroad car shipping to urban markets. Each apricot is selected, tissue-wrapped, and hand-placed for quality. The next stop was the fruit exchange in New York City. (ECCHS.)

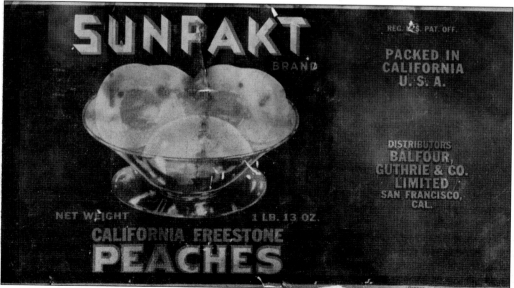

Sunpakt brand peaches packed in metal tins ensure flavorful peaches year-round. Prior to airfreight, fresh fruit out of season was impossible. Pressure cooking and preserving in cans made production of fresh fruit as a commodity product possible. The famous Georgia peach has nothing on these beautiful freestone peaches.

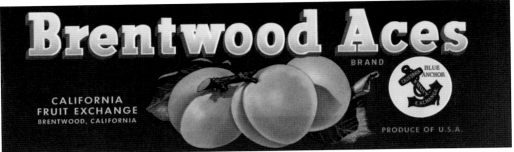

The California Fruit Exchange survived 99 years as one of California's longest-lasting fruit cooperatives and historic businesses. Brentwood Aces brand apricots were hand-selected, tissue-wrapped, placed in egg flats, and shipped to New York City for the carriage trade. Distinctive fruit box labels, such as this one, are highly collectable by ephemera enthusiasts today.

Pear tree cultivation lends itself to orchards located on reclaimed marshland. The Bartlett pear will withstand blight and tolerate wet roots, unlike most genus *prunus* trees like cherry, nectarine, peach, plum, and apricot. Also, unlike most fruits, pears can be picked green and will ripen in transit to market. Pears are delicious eaten fresh or preserved for enjoyment out of season.

This aerial photograph taken of the Oakley, Knightsen, and Brentwood area shows the impact that irrigation can have on a community. Previously dry farming of grains is transformed into high-yield fruit and nut tree production. A farmer with 20 to 40 acres could sell his crop through one of the commodity marketing exchanges and economically compete anywhere in the world. (ECCHS.)

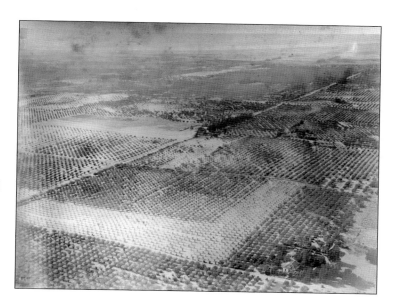

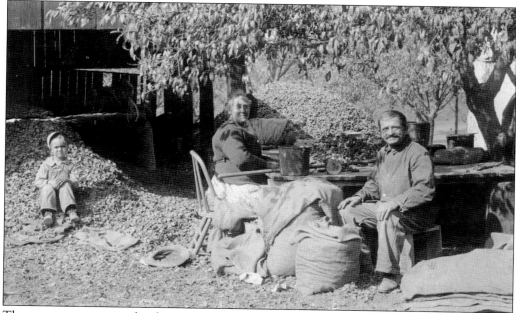

There was opportunity for the very small farmer, cultivating less than 20 acres, to prosper in Contra Costa County. Hulls surround this family, working on their August almond harvest, as they sort meats from the shells. The by-product hulls have a value as high-protein cattle feed. The family may have a cow for fresh milk and a few chickens, but they are not subsistence farmers. They raise one crop, and pray for volume and a good price.

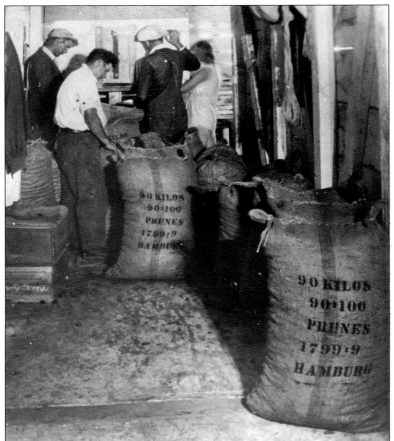

Plums dried to prunes are packed in burlap bags and moved for transport to Hamburg, Germany. Fortunately, plums dried in air or in sulfur will withstand the long sea voyage to Europe with little spoilage. The secret is the natural preservative sugar content of the fruit, which is enhanced by the drying process. (AHS.)

Form 64-1m 1 10-18

$ 15.07 San Jose, California, _____ JULY 1ST 19121 No. A-18

SIX - 6 / - MONTHS after date, for value received, at its office at San Jose, Cal., the

CALIFORNIA PRUNE AND APRICOT GROWERS, Inc.

PROMISES TO PAY TO _____ J. B. OGIER _____ MAR 22 1922 _____ OR ORDER

FIFTEEN AND -07/100 DOLLARS

with interest payable semi-annually at the rate of six per cent per annum from date until paid, both interest and principal payable in United States Gold Coin.

IN TESTIMONY WHEREOF the proper officers of said Corporation under authority of a resolution duly adopted by its Board of Directors have hereunto signed the name of the Corporation and affixed its Corporate Seal.

California Prune and Apricot Growers, Inc.

BY _____ President

BY _____ Secretary

Due _____

The sphere of influence cast by Juan Batista de Anza, founder of San José and establisher of Mission San José, is still felt over 100 years later. San José drying yards concentrated on plums. The largest fruit-drying sheds in California were in Oakley, where apricots were dried and shipped. Corporate headquarters for food distribution and export stayed in San José.

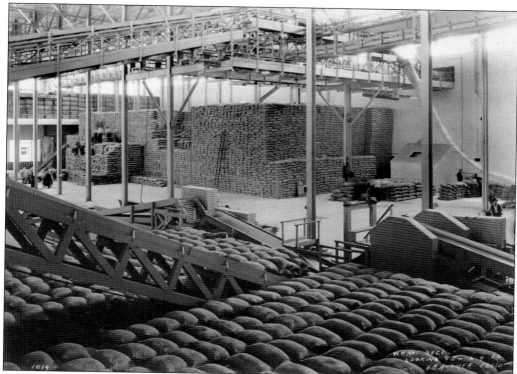

The vastness of commodity shipping can be grasped by the volume of sacks in this one warehouse. Most agricultural commodities—including potatoes, prunes, grains, nuts, and onions—were sacked and transported by hand trucks or conveyers. Loose product poured into silos, bins, or tank transport is a modern, container-ship phenomenon. (CSL.)

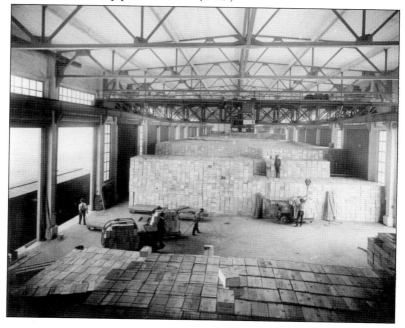

Individual canned-goods cases in this warehouse are moved in preparation for shipping. Note that each box is separate and not palletized for ease of handling. Each load of cases would be brought on board the ship and individually stowed. There were many jobs for dockworkers and laborers moving materials. (RICH.)

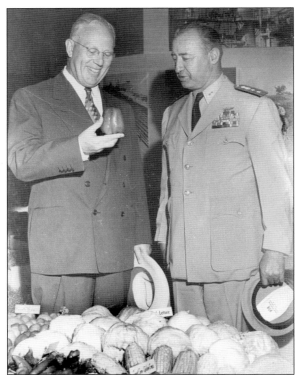

Gov. Earl Warren (left) admires produce from Contra Costa County at the California State Fair in Sacramento. Warren was governor of California from 1943 to 1953, before he was appointed to the United States Supreme Court. Warren was a University of California, Berkeley graduate and longtime attorney and resident of the Bay Area. He was a frequent visitor to and political ally of Contra Costa County. (CCCH.)

Contra Costa County's connection with the romantic age of steamboat transportation continued in its iconography into this 1940s-era agricultural exhibition at the California State Fair. Fresh fruit and vegetables and home-canned produce in glass jars were presented in competition with goods from other California counties. Contra Costa products consistently took first prize. (CCCH.)

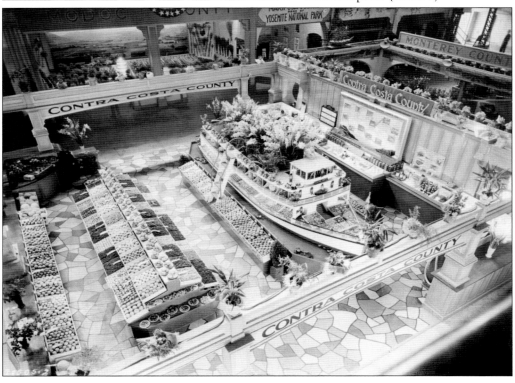

Five

FACTORY AND MINING

Shipping access and real estate were the keys to maritime Contra Costa County success. A list of land ownership and manufacturing plants along the coast reads like a who's who of San Francisco and United States industrialists of the 19th century. Production of bricks, asbestos, rubber, paper, ceramic fixtures, chemicals, electricity, steel, iron, munitions, and alcohol relied on local raw materials to create finished goods. Assembly production plans at one time included shipyards, Pullman railroad cars, and Ford motorcars. Warehousing and distribution centers included Winehaven for bottling and cellaring California wines, Balfour Guthrie & Co. wharf and grain warehousing, and the California Fruit Exchange.

Just about every product mined or manufactured in Contra Costa County can roll downhill from the county's geographical epicenter. Cinnabar ore mined along Marsh Creek was horse-drawn down the creek to shallow draft barges loading at Antioch or Babe's Landing. The major coal mines at Nortonville, Judsville, Stewartsville, and Somersville transported their ore down to Pittsburg and Antioch for transshipment to San Francisco. The tiny locomotives heading the coal cars served more as a break against gravity than as engines. Later, high-grade sand mined in East County would find its way into Gallo wine bottles, scientific laboratory glass, Irish Waterford crystal, and silicon chips.

Oil, too, flows downhill. The "Big Four" California oil refineries—Associated Oil, Shell Oil, Union Oil, and Chevron Oil—are located along the San Pablo Bay crescent from Richmond to Martinez. Crude oil and natural gas is piped from wells located as far south as Bakersfield and Coalinga. Raw oil product heated to ensure liquidity follows the natural gravity watercourse north alongside the San Joaquin River with the aid of pumps. Natural gas, discovered in the 1960s in East County and piped from Canada, joined the mix at the refineries. Petroleum products, including gas, diesel, and lubricants, are then shipped out from the refinery docks. The oil tankers take petroleum products out, but do not bring unrefined oil in.

Contra Costa County, California

Contra Costa County is in the geographical center of California, within fourteen miles, at nearest point, to San Francisco. Has seventy miles of water front, nearly all of which is deep water.

THAT'S THE PLACE

PACIFIC OCEAN

Transportation Facilities

Has best transportation facilities of any point in the world. The main lines of the Southern Pacific Railroad and the Atchison, Topeka and Santa Fe Railroad Company run through the County. The latter has its terminus, with large yards and shops, at Point Richmond, in this County. The Great Western Pacific has made its survey through the County and its Surveyors are now in the field making surveys for actual work of construction of road. Besides these three main lines, numerous steamers ply between the different wharves and numerous landings along the shore line and San Francisco.

CLIMATE:—The climate is healthful, mild and equable. It is tempered by the influence of the Pacific Ocean, the waters of the San Pablo, San Francisco and Suisun Bays and the San Joaquin River. All but the first-named wash the Northern and Eastern shore of the County. The mean annual temperature is between fifty-two and sixty-eight degrees.

AREA:—The County contains 440,000 acres of land. Four-fifths of this area is under cultivation.

PRODUCTS:—Wheat, hay, barley, oats, fruits in all variety, table grapes, wine grapes, garden truck, asparagus, and all kinds of vegetables and berries, oranges, limes, olives, raisins and figs, almonds, walnuts and various kinds of dried fruit.

RAINFALL:—The average rainfall ranges from 18 to 23 inches. Drought never known.

IRRIGATION:—Irrigation not required.

SOIL:—Rich, alluvial and very productive.

EDUCATIONAL:—Contra Costa County has five well-equipped High Schools, sixty Grammar Schools and 110 teachers.

MANUFACTURING:—Cheap factory sites and cheap transportation by water and rail to all points of the world have induced many manufacturers to locate along our shore line. These inducements, together with low expenses, freedom from labor difficulties, electric power, crude oil for fuel (the Standard Oil Company's pipe line passes through the County within one mile of the water front), make Contra Costa County unexcelled as a location for factories.

LANDS:—Lands for vineyards can be bought at from $50 to $100 per acre. These lands will produce from four to ten tons per acre, and the grapes have been selling for the past three years at from $20 to $30 per ton. Wheat lands can be bought at from $30 to $100 per acre. These lands will produce from 15 to 25 hundredweight of wheat per acre. Vineyards in full bearing can be bought at from $200 to $500 per acre, orchards in full bearing at from $150 to $250 per acre.

For data as to cost of living, building, wages or any other information, communicate with

Contra Costa County Board of Supervisors, Martinez, California

The economic history of Contra Costa County has mirrored the rise of an industrial revolution in the United States in transportation, manufacturing, and agriculture. California gold and its 19th-century silver colony, Virginia City, financed post–Civil War economic development. Miners needed meat, fish, and bread to sustain them in the pursuit of gold and silver. Contra Costa provided the cattle, salmon, and wheat flour. Iron manufacturers forged the equipment necessary for Nevada hard rock mining. Contra Costa provided the coal. Lead, paper, steel, ships, armament, canned fruits and vegetables, and men were required to win 20th-century wars. Contra Costa smelted, manufactured, armed, raised, processed, and volunteered. Moreover, all these contributions are thanks to the 100-mile shoreline and the maritime transportation industry that flourished. Not surprisingly, the board of supervisors touted the schools, climate, and business environment to attract new businesses, employees, and families to make their homes in Contra Costa.

Original and modern Argonauts looked to blasting powder manufactured along the San Pablo peninsula to pull gold from California rivers and mines. This placer miner displays the color (gold) in his pan after washing at a stream. The presence of a Giant Powder Co. box of dynamite on a wire indicates this miner has blasted a hole in the mountainside. After blowing up the granite and quartz, the miner can extract the desired mineral.

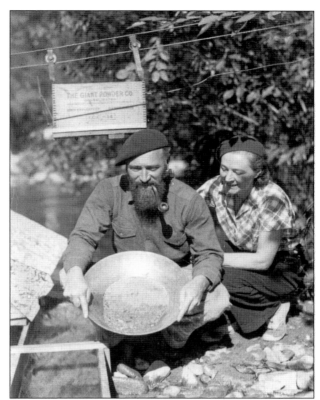

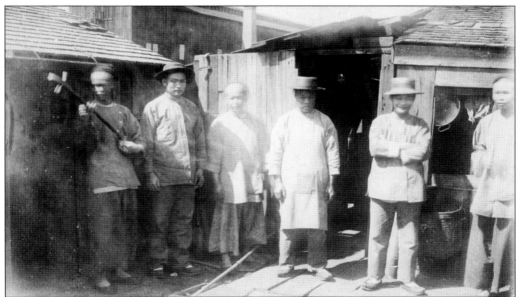

Manufacturing of nitroglycerin was dangerous work and required steady hands. The compound was used by Chinese road crews to blast through the Sierra Nevada as the Central Pacific railroad worked its way east to connect with the Union Pacific. Nitroglycerin is notoriously unstable; many Chinese workers died while using it to clear the way for the railroad. (RICH.)

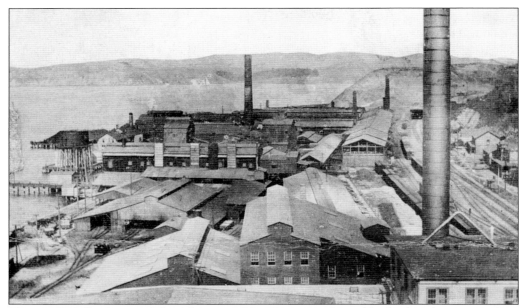

Thomas H. Selby (1820–1875), 13th mayor of San Francisco, formed his lead smelting, pipe, sheet metal, and ammunition manufacturing business at the end of the Civil War. The Selby Shot and Smelting Works relocated from its separate North Beach and First and Howard Streets location in San Francisco and consolidated operations in more rural, less populated Contra Costa, which had the larger land area necessary for expansion and access to deepwater transportation. (KP.)

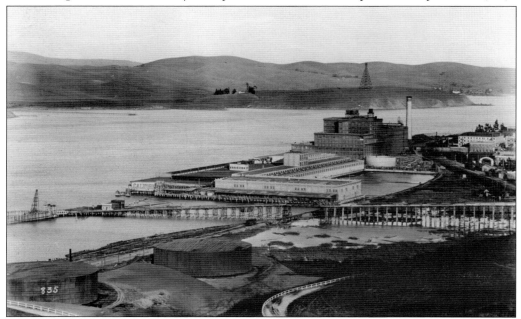

The Sugar Factors Company purchased the mill in 1905 and began its operation as the California and Hawaiian Sugar Refining Corporation in 1906. The company was cooperatively owned by 33 major sugar plantations in Hawaii. It processed 80 percent of all the sugar produced in the islands. Matson Navigation Lines transported the raw sugar from Hawaii to Crockett. (CSL.)

The Giant Powder Company, established in 1868, relocated from San Francisco to the little company town aptly named Nitro at the base of Albany Hill in 1892. The company was the first commercial manufacturer licensed by Alfred Nobel to make dynamite in the United States. Giant relocated, as most hazardous manufacturing plants did, to Contra Costa County after its previous two plants exploded. After the final catastrophic explosion leveled most of the company town, its narrow-gauge railroad was purchased by Walt Disney. It is still a feature of Disneyland California.

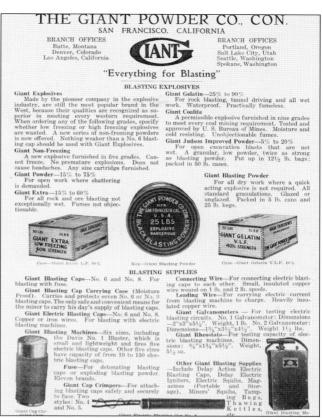

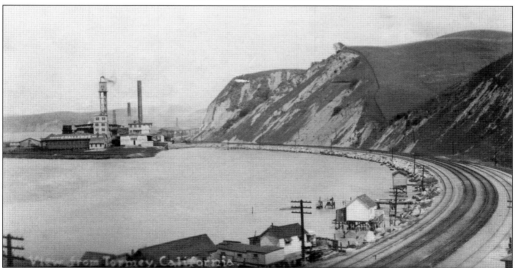

Selby Challenge Metal was the largest smelter of lead, gold, and silver in the western United States. Selby smelted much of the ore from the Sierra Nevada foothills and Virginia City. He purchased a large tract of land from Patrick Tormey and moved his plant to Contra Costa in 1884. The area around the smelter, consisting of private homes and company housing, became known as the town of Selby. (KP.)

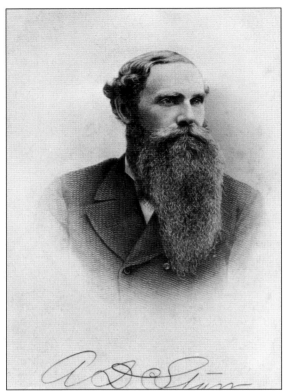

Abraham Dubois Starr (1830–1894) from Ohio was a successful forty-niner gold miner who turned his stake into a successful business, providing goods to miners and settlers. Observing the demand for beer and bread, Starr started milling grain in Marysville in 1857. Starr was a friend to politicians, railroad barons, and socialites. He served as a railroad director and Republican Party delegate, and became the most successful miller in the world. (CHS.)

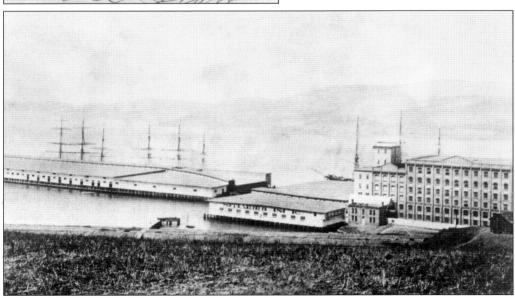

Starr responded to demand and relocated closer to California's population center by building the world's largest flour mill in Vallejo in 1869. That facility eventually reached production capacity, motivating Starr to build an even bigger flour mill in 1891 at Wheatport, today's Crockett, with a milling capacity of 8,000 barrels of flour a day. The bank panic of 1893 bankrupted Starr, and George McNear, the "Wheat King," purchased the plant. (CSL.)

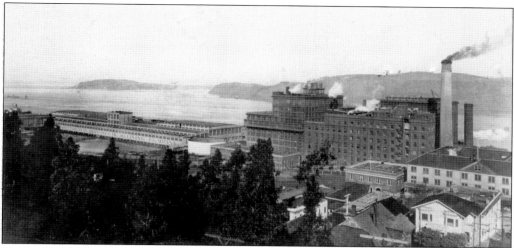

George W. McNear (1838–1909) manufactured flour at the Starr Mill until it was converted to a sugar beet and cane sugar refinery in 1898; peak grain production days had passed and alternative uses were sought. Sugar beet refining was short-lived too. The mill was acquired in 1906 for sugar cane refining by the California and Hawaiian Sugar Refining Corporation (C&H Sugar). It proved to be most profitable to grow the cane in Hawaii and ship raw sugar to California for final refining.

The Iconic C&H sugar cane kids are shown here enjoying fresh-cut sugar cane from the stalk. Hawaiian children sang the company jingle, "C&H, C&H, Mommy uses it to bake our cakes. It's the only pure cane sugar from Hawaii. That's our sugar!" to advertise the superiority of cane sugar over beet sugar.

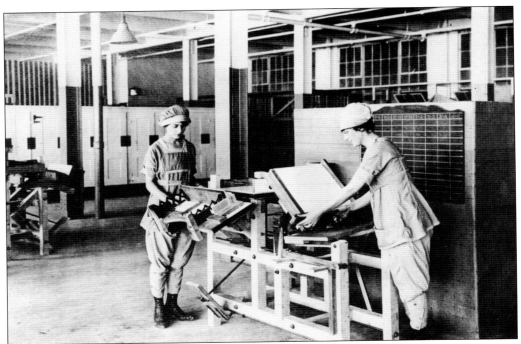

Women stretch, stencil, and prepare sacks for filling at the C&H factory in 1910. Note the attention to cleanliness and safety, with uniforms consisting of pantaloons, not skirts; leggings gathered from knee to ankle as if a gaiter; and hair caps. These women must have worked fast, as the C&H plant processed 67,000 tons of sugar in 1910 while employing 490 people. (CCCH.)

Flour- and sugar-sack towels were preferred by most homemakers for drying dishes for most of the 20th century. Tightly woven, clean, white, and soft, they were found in almost every kitchen at a time when normal quantities of flour and grain were purchased in 100-pound bags for daily home baking of bread, pies, and pastries. Personalized with embroidery, they became shower gifts for soon-to-be brides. The National Recovery Administration (NRA) eagle logo was displayed proudly by industry showing support for fair prices, minimum wages, and maximum weekly hours during Roosevelt's New Deal legislation passed in 1933.

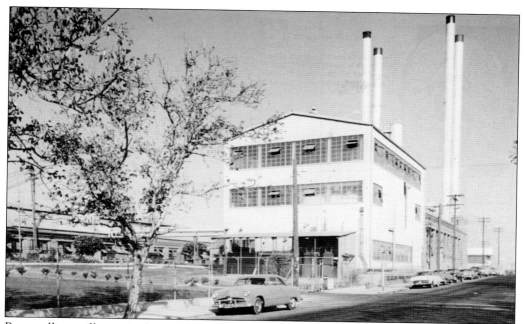

Paper rolling mills required as much water as timber to produce paper. The ease of moving timber by water and the availability of wood by-products from lumber milling operations along the river made paper mills a complementary industry. The Crown Zellerbach Corporation, a forest-products company based in San Francisco, had paper mill operations in Antioch.

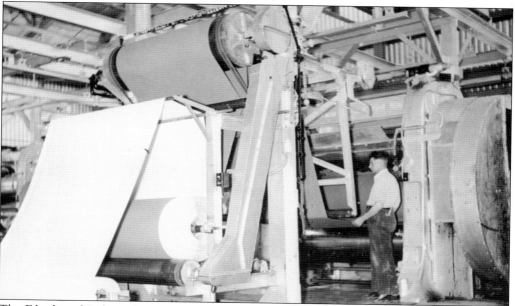

The Fiberboard Pulp and Paperboard Company in Antioch produced paper products ranging from fertilizer bags to milk cartons. The corporation was a diversified forest-products company with financial interests in timber and lumber companies. Fiberboard, as an early collaborator with the California Pollution Control Financing Authority, issued tax-exempt bonds in 1974 to reduce air and water pollution from the facility. (PIT.)

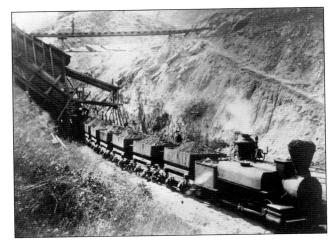

Soft coal discovery in the eastern foothills of Mount Diablo created a coal rush in 1858. The towns of Judsville, Somersville, Stewartsville, West Hartley, and Nortonville were populated overnight. In 1870, half of the 8,500 people of the county lived in the coal-mine towns. The town of New York of the Pacific instantly changed its name to Black Diamond, after the coal-mining company. Locomotives brought coal down to the river, where it was barged throughout the West. (PH.)

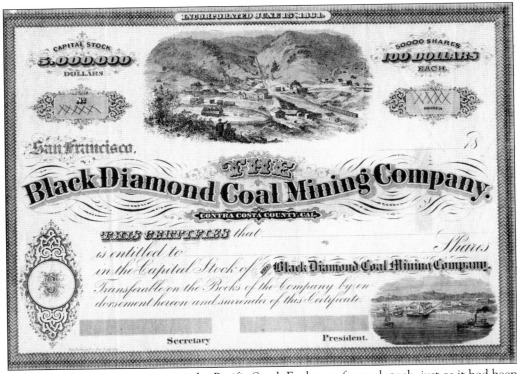

Stock speculation was rampant at the Pacific Stock Exchange for coal stock, just as it had been for silver stock from the Comstock Lode. Speculation in shares was perhaps as lucrative as discovering the coal seam. The Black Diamond Mine Company was one of the most successful. The Brentwood Coal Mine, with which Charles Marsh, son of Dr. Marsh, hoped to recover his Los Meganos fortunes, proved a bust. (PIT.)

Oil was discovered in Kern County in 1865, and the first commercial drilling operations began in 1872 along the Kern River Oil Fields. Oil fields came into production and were played out in a boom-and-bust cycle lasting into the 1920s. Entry of major corporations, particularly Standard Oil, brought significant investment capital to oil field operations, including completion of oil and natural gas pipelines to its Martinez manufacturing plant in 1910.

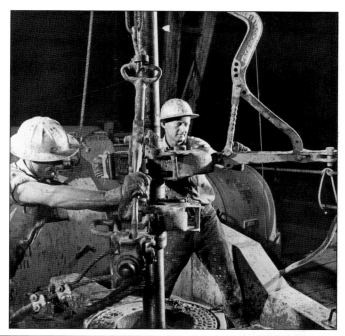

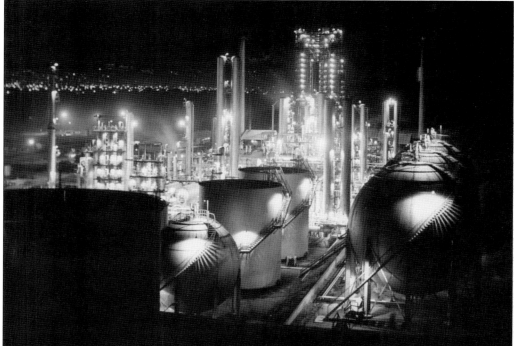

Oil refineries came to dominate the San Pablo Bay crescent from Martinez to Richmond. Shell Oil launched its refinery at Martinez to process oil primarily from Kern County. Associated Oil Company at Avon processed oil primarily from Coalinga Oil Fields. Union Oil was located at Olema. Standard Oil (now Chevron) formed its operations at Richmond. All drew their oil and gas raw materials from pipelines that ran from the interior of the state.

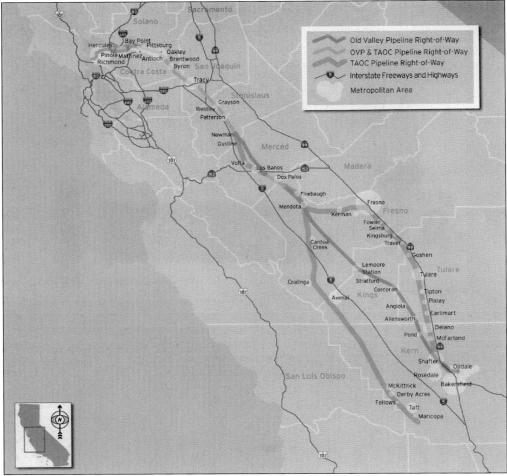

Old Valley Pipeline Right-of-Way
OVP & TAOC Pipeline Right-of-Way
TAOC Pipeline Right-of-Way
Interstate Freeways and Highways
Metropolitan Area

Coal was the industrial energy source of choice in the 19th century. Oil replaced coal in the 20th century for ships, industry, and manufacturing. Contra Costa transitioned quickly, building the major oil refineries for the West Coast at Martinez and Richmond. The Tidewater Associated Oil Company (TAOC) and Old Valley Pipeline (OVP) were constructed in the early 1900s and carried crude oil from the southern San Joaquin Valley to the Richmond refinery. The OVP consisted of approximately 280 miles of pipeline, 21 pump stations, 4 tank farms, and 2 reservoirs. The TAOC pipeline system consisted of approximately 789 miles of pipeline and 56 pump stations. Operations ceased for the OVP in the 1940s and in the 1970s for the TAOC pipelines. The pipelines were originally installed at depths ranging from 18 inches to 10 feet below ground surface. The steel pipelines were typically encased in a protective coating composed of coal tar and asbestos containing surface coating material (ACM). When pipeline operations ceased, the pipelines were taken out of commission. Chevron maintains these pipelines today by performing cleanup and remediation. (Chevron Historical Pipeline Portfolio of Maps.)

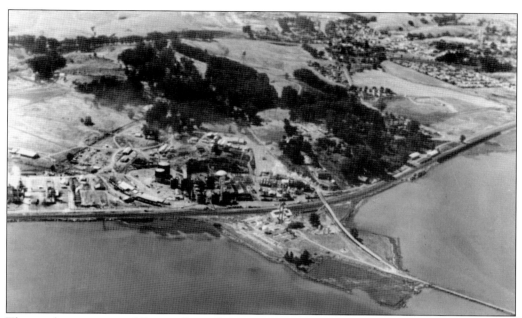

The northernmost tip of Contra Costa County is Point Pinole. Here, oil tankers took on product from refineries and tank farms. Refineries were established from Martinez to Richmond years before the city of Richmond was incorporated in 1905. Standard Oil began construction of the refineries in 1901 in response to major oil field discoveries in Kern County. Standard Oil's first headquarters were in an abandoned farmhouse. Additional refineries were constructed to process oil and gas discovered in the Coalinga oil fields. The rivalry between Royal Dutch Shell Oil and Standard Oil was particularly stiff, with Standard Oil manipulating oil prices to a low of 10¢ a gallon in an attempt to bankrupt the competition in the 1920s. (Both, CHS.)

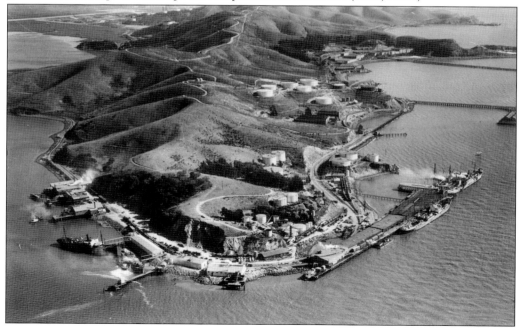

The cover of a promotional brochure proclaiming Pittsburg as an industrial center leaves no doubt about the importance of steel. The town has embraced coal and steel since coal was discovered in the nearby hills, precipitating a name change from New York of the Pacific to Black Diamond, after the mines. The location of the Columbia Steel company on its shores inspired yet another name change in 1911. The Columbia Steel hot forge operation features prominently in the background of this image. Access to the natural gas and oil needed to fire the furnaces and sand for casting from the local mines made this an ideal location. The steel industry still has an economic presence in Pittsburg today; however, it is steel imported from Asia. USS-POSCO Industries (a joint venture between US Steel and POSCO of South Korea) imports product to Pittsburg, where it is cold rolled and transported by train throughout the United States. Uncapped air pollution would hardly be tolerated today, but in 1930, the smoke was a symbol of prosperity.

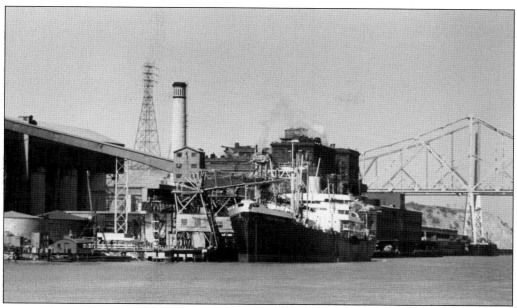

Matson Navigation Lines ships docked at the C&H Sugar refinery pier at Crockett to deliver raw sugar from the plantations in Hawaii. Consolidation of refining operations at Crockett provided efficiencies of manufacturing and of distribution and marketing of finished product. Planters refining sugar on the islands was limited to selling for local consumption. Those participating in this cooperative sold sugar to the world.

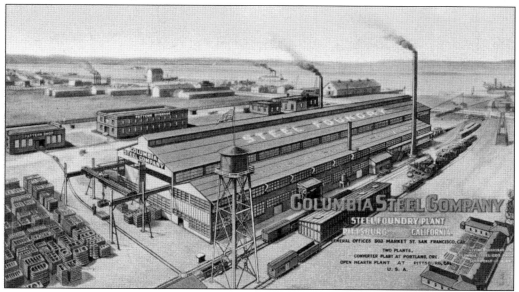

The Columbia Steel Company located at Pittsburg grew because of the easy availability of coal to fire its furnaces. Raw material was shipped in and finished steel was shipped out. The plant's location away from urban areas, with river water for cooling and a specialized skill population, made Pittsburg yet another company town dedicated to producing one product. The US Steel plant closed its American Bridge Division Plant in 1978, citing illegal flooding of foreign steel into the US market.

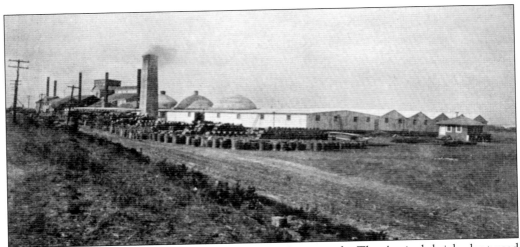

Brickmaking operations were established all along the riverside. The Antioch brick plant used local clay to fashion and bake bricks for construction. Again, natural resources consisting of clay, water, and coal for baking made brick manufacturing a natural industry for the area. Bricks were loaded on a barge and inexpensively shipped downstream to the rapidly growing cities of Oakland, San José, and San Francisco.

At the foot of Jost Distillery Pier stands the brick house built and occupied by Thomas Gaines (1830–1885?). Gaines was born in New York, presumably as a freeman. His house stands just feet outside the Antioch city limit line on the old Los Medaños land grant. African Americans were not allowed to reside in Antioch and tradesmen of color had to be out of town by sundown. Gaines's choice to build his brick house and reside inches over the disputed city limits line on unincorporated county land was hotly disputed. (AH.)

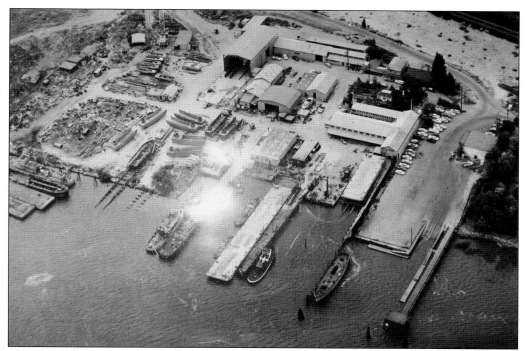

The Antioch riverside in the 1960s was still a bustling small business locale with small-boat builders, launching ramps, warehouses, marine salvage, and a shipyard. Homes and gardens (far right) existed side by side with industry. (AH.)

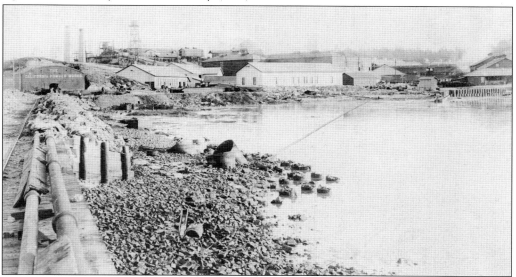

The California Powder Works—and similar nitroglycerin, dynamite, and TNT manufacturers along the Contra Costa shore—relied heavily on the availability of nitrogen as raw material for production. Large populations of seabirds and millennia of guano buildup on the Farallon Islands and along the Pacific coast provided saltpeter, the natural source of nitrogen for these early powder operations. By 1913, Chile had become a major exporter of fixed nitrogen to the world, including California.

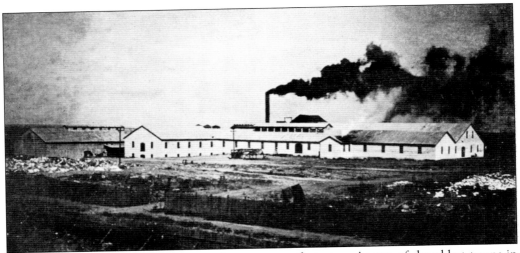

Antioch has had a long association with paper manufacturing. As one of the oldest towns in the county, it has embraced every possible manufacturing scheme and mineral discovery to promote employment and its citizens. Fiberboard Paper and Pulp milling was Antioch's last major manufacturing employment stand before it transformed into a bedroom community, offering affordable housing to a population forced farther and farther east by skyrocketing housing prices in the Bay Area in the 1990s. (AH.)

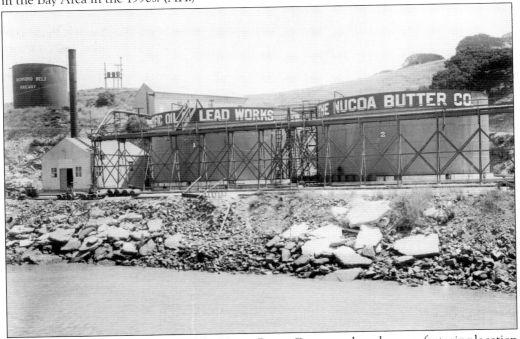

The Pacific Oil and Lead Works and the Nucoa Butter Company shared a manufacturing location in Contra Costa County. Nucoa produced a World War I–era butter substitute, better known today as margarine. It is a hydrogenated vegetable oil product that is whey-and-dairy-free. It has a long shelf life and will withstand extreme temperatures without going rancid. The recipe has changed many times since 1917, but it still relies on vegetable matter as its main ingredients, quantities of which are by-products of manufacturing in Contra Costa County.

Six

FOREIGN WARS AND HOME FRONT

World War I gave maritime Contra Costa County its entry into the shipbuilding business. Production and maintenance of vessels was initially located at Black Point, near present-day Vallejo, where the Pacific Steam Navigation Company established its shipbuilding operation in the 1850s. San Francisco quickly entered the shipbuilding business near Potrero Point, where the Union Iron Works created hulls and the Risdon Iron Works installed power supplies and infrastructure. Wooden boatbuilding for the fishing industry and river craft was well established from Martinez to Antioch at the same time. Transitioning to steel-hulled ships for cargo and fast-motor torpedo boats, later known as PT boats, was a natural next step for these shipbuilders given the proximity of coal, hot steel forges, and rolling mills that were well established after 1900.

Most famous are the Kaiser shipyards, located in Richmond and four other shipyard locations around San Francisco Bay. Liberty ships were assembled with unbelievable speed at these Richmond shipyards. The record time from keel laying to launching, loaded with cargo, and passing under the Golden Gate Bridge was less than four days. Nearby, women with small fingers, skilled in detailed handwork, were employed in the delicate business of ammunition assembly. Major weaponry was stored and shipped from Port Chicago. Ships fueled at Winehaven, which was commandeered and renamed Point Molate Naval Fuel Depot by the Navy in 1941, and steamed to the Pacific war theater.

River steamboats, notably the *Delta King* and *Delta Queen*, were pressed into World War II military duty, thereby prolonging their serviceable lives. Gen. Jimmy Doolittle was convinced that the major San Francisco Bay bridges would be the first targets should the Japanese fleet reach California. Because of this possibility, transportation of servicemen and -women to Fort Mason, San Francisco, where they would embark for the Pacific theater, required reliable transport that was not dependent on the San Francisco–Oakland Bay Bridge. Both the *Delta King* and *Delta Queen* were requisitioned, painted battleship gray, and served as USS *YFB-55* and USS *YFB-56* respectively for the duration of the war. Camp Stoneman, Pittsburg, saw all military personnel embark and return from World War II and the Korean War.

The Contra Costa maritime industry boomed during World War II. All the shipyards enjoyed full employment. Agricultural product traders speeding to the San Francisco commodity market first used the fast boat designs created at Hacker Craft in Stockton to beat their competition. Later, the same swift boats were employed in the rum-running trade to outrace Treasury Department agents. Finally, these hull designs were modified into the fast torpedo boat design known at the PT boat. (AH.)

USN *442* is launched down the Fulton Shipyard ways at Antioch. Her hull comes from Hacker Craft in Stockton. Henry Kaiser of Kaiser Permanente Shipyard fame had his personal speed launches built in Stockton and promoted these marine engineering prototypes to the US Navy. George Whittell's *Thunderbird*, familiar to Lake Tahoe visitors, was a twin-engine prototype for the PT boat. (AH.)

This steel casting of a marine horn and trunk for a Liberty ship weighs 15,000 pounds. It is ready for transportation and installation at the Kaiser Shipyards in January 1945. Columbia Steel, a subsidiary of US Steel, had a 43-acre foundry in Pittsburg. This is one of the many examples of contractors providing materials and supplies directly to the maritime effort that was critical to winning World War II. (SFPL.)

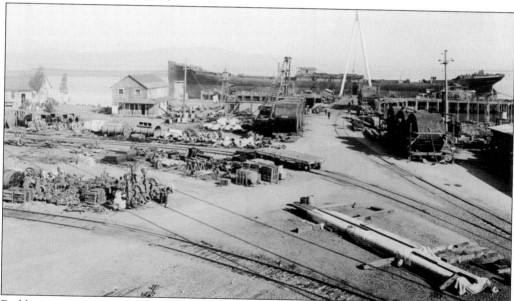

Building cargo ships during World War I provided Contra Costa County the opportunity to seriously enter the metal ship industry. Contracts for constructing military ships and steel-hulled private ships had been almost exclusive to Union Iron Works and its subcontractors in San Francisco. Robert Burgess secured a government subsidy from the US Shipping Board to build private cargo and tanker ships. He established the Pacific Coast Ship Building Company, organized in 1918, at Port Chicago. (CHS.)

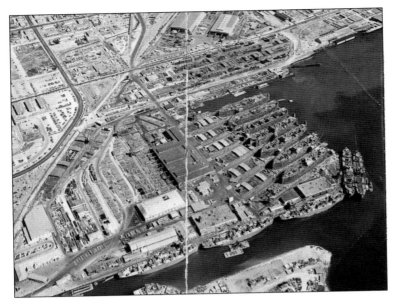

This aerial view shows the Permanente Metals Corporate Yard, which was the first of four yards built at Richmond at the height of the Liberty and Victory cargo ship building program. The shipyard stands on reclaimed land, which was a mudflat prior to January 1941, when construction of this facility began. Ships at various stages of completion are seen on the seven ways. (SFPL.)

This image of the shipways at Richmond Shipyard Number 3 was taken from a ship that had just floated and launched. As many as two ships a day were launched at the height of production. Once the hulls were launched, the ships were towed along the channel pier for rigging, fitting, and final preparations for loading cargo. A total of 1,490 ships were launched from Shipyard Number 3 from 1942 to 1945. (CHS.)

The iconic Rosie the Riveter, shown here, was key to the prefabrication and modular construction of Liberty and Victory cargo ships assembled at the Kaiser Shipyards. Richmond was the home of full employment, bringing Americans out of the Great Depression with a chance at the American dream. Average wages in United States shipyards were $2.71 per hour in 1959, higher than anywhere else in the world.

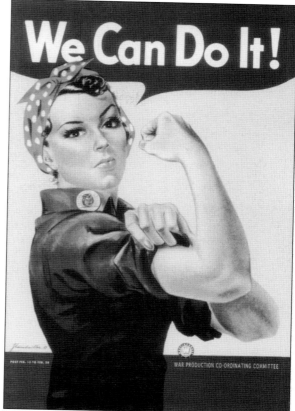

The Kaiser Shipyards, viewed here in the 1960s, was a ghost town awaiting its future. It found new life as the Port of Richmond after being modernized in 1980 with new container ship loading capabilities. The port was ranked first in volume of liquid bulk and automobiles shipped in 1980 in the West. This port ended San Francisco's life as a major merchant shipping port. Finger wharves are now a thing of the past. (SFPL.)

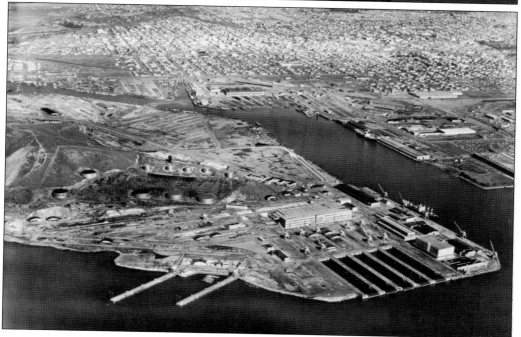

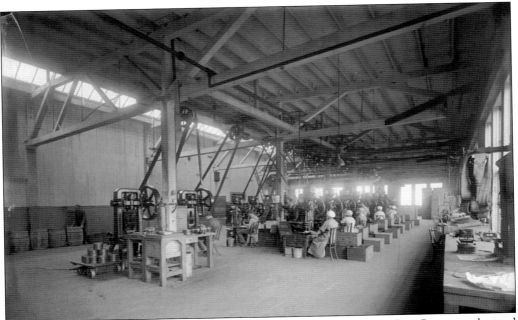

The Pacific Cartridge Company in Stege was owned by the California Cap Company, located at what is now the University of California, Berkeley's Richmond Field Station. The facility manufactured all components of ordnance, including explosives, shells, and blasting caps. The assembly line was staffed primarily by women doing detailed, delicate, and important work.

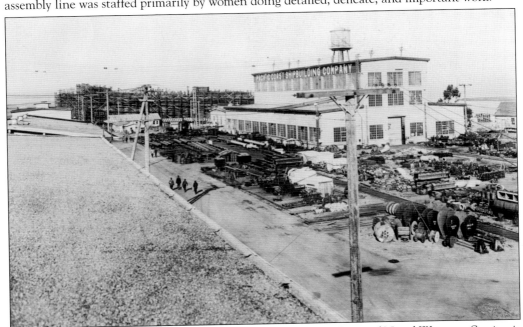

The Pacific Coast Ship Building Company, located where the Concord Naval Weapons Station is today, produced ten 9,600-gross-tonnage cargo ships of the same design, some of which provided service in the Hawaiian and South Pacific trade. The less lucky were torpedoed or lost to mines in World War II. (CHS.)

Sailors learned the technical skills required to transfer oil and fuel safely at Point Molate Naval Fuel Annex Tank Farm School (Winehaven) from instructor George King. This image suggests an integrated classroom including African American enlisted men. It must have been taken after the Port Chicago Mutiny and the Navy's moved to integrate forces in February 1946.

Izumi Taniguchi, age 18, was a student at Liberty Union High School in Brentwood and was interned in compliance with Executive Order 9066 on April 24, 1942. Taniguchi, a true hero, volunteered as an M.I.S. interpreter in the Pacific. After the war, he pursued a college education, earning a doctoral degree, and concluded his career as professor emeritus of economics at California State University, Fresno. A Liberty High School diploma was conferred upon him posthumously as part of the 2005 Nisei High School Program. (LIB.)

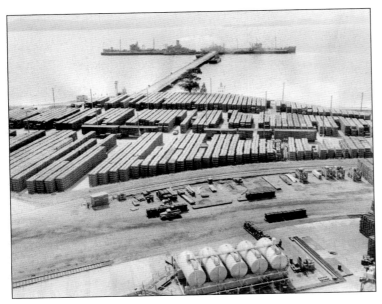

Winehaven, the Napa and Sonoma winery storage and distribution facility, is located in Richmond. The Navy acquired the facility in 1941 as a naval fuel depot, due to its proximity to the major oil refineries. Here, individual cans of fuel are on the dock, ready to be transported as cargo to the waiting dockside ships. The fuel depot became part of the Oakland Naval Supply Center in the 1950s (SFPL.)

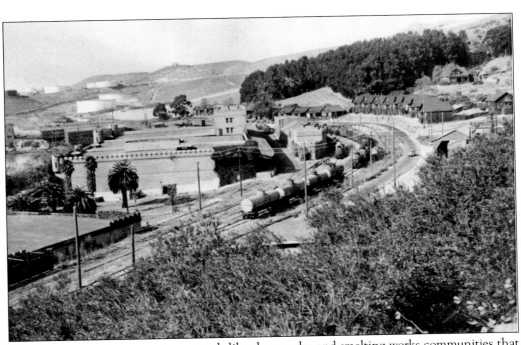

Winehaven was a company town, much like the powder and smelting works communities that dotted the San Pablo peninsula. The property was decommissioned in 1990 but has been designated a government Superfund cleanup site and unused for much of the last 60 years. The property is presently owned by the Guideville Band of Pomo Native Americans, who, in 2000, proposed to build a five-star resort hotel and casino on the site.

Camp Stoneman, located in the marsh lowlands of Pittsburg, was the major military base for soldiers awaiting orders and ships to carry them to the Pacific in World War II. The base also held Italian prisoners of war in dubious status once Italy capitulated in 1943. Japanese prisoners were also held and interrogated here as they traveled from the military-appropriated immigration station on Angel Island to the military interrogation facility at Camp Tracy in Byron.

Soldiers returning from World War II action in the Pacific and the Korean War disembarked at Camp Stoneman as well. This welcoming sign along the wharf was the first thing sailors and soldiers saw as they approached home. They were discharge from military duty in a matter of hours after their arrival.

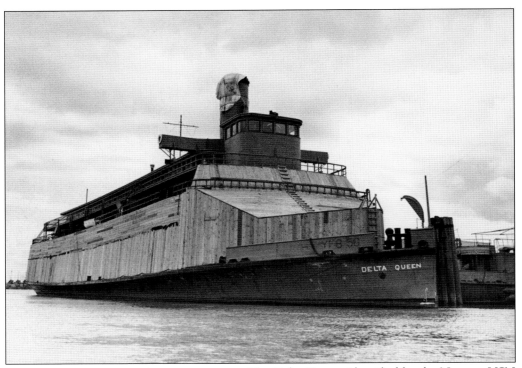

The *Delta Queen*, identified by the Navy as USN YFB-56, provided transport service throughout the war. Once released from service, she too mustered out of service at Camp Stoneman and was boarded, smokestack tarped, retired from service, and placed in the mothball fleet in Suisun Bay on August 28, 1946. She was the only ship to arrive at the 500-ship ghost fleet under her own power. (CCCH.)

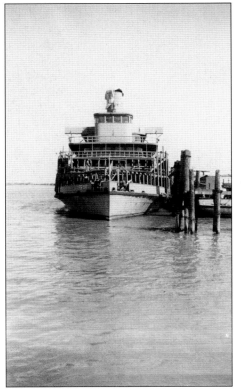

In September 1947, the US Navy sold the *Delta Queen* out of the ghost fleet at auction for $46,250 to Green Line of Cincinnati, Ohio. She relocated to the Fulton Shipyards in Antioch, where her sides were planked and her paddle wheel removed to be made seaworthy for a tow trip through the Panama Canal to New Orleans. She arrived in May 1947 for restoration and retrofit. Her first voyage up the Mississippi was in June 1948. The ship is now a floating National Historic Landmark cruising up and down the Mississippi. (CCCH.)

The car ferry *Yerba Buena* was also pressed into military service. Members of the 936th Field Artillery Battalion remembered her as their departure ship as she ferried the troops to San Francisco in January 23, 1951, when they embarked for Korea on the USNS *General CG Morton*. They returned to San Francisco on the USNS *General MC Meigs* and transferred once again to the *Yerba Buena* for final disembarkation at Camp Stoneman on February 14, 1952. (SFPL.)

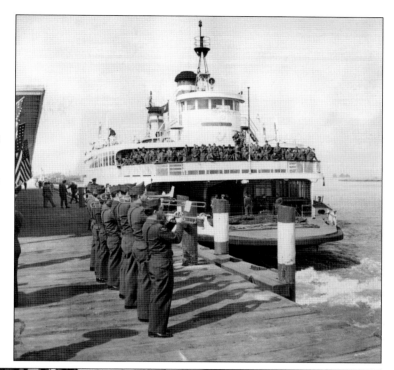

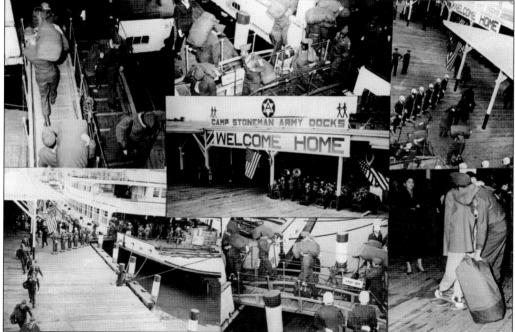

This Camp Stoneman montage captures the happiness experienced as veterans are welcomed home from the Korean War in November 1951. Within 24 hours, 8,500 homebound service members and their replacements swapped places and shipped out of this port. Over 100,000 individuals were processed out of this facility during the Korean War. Thank you, soldiers! (SFPL.)

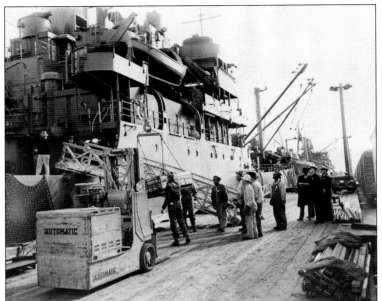

All ordnance destined for the Pacific in World War II shipped from the naval weapons station located at Port Chicago. Civilians and sailors were engaged in loading munitions on board military transport vessels. In July 1944, munitions detonated while being loaded onto a ship, killing 320 and injuring 390. The entire town was affected and damaged by the explosion. African Americans casualties were especially high. (SFPL.)

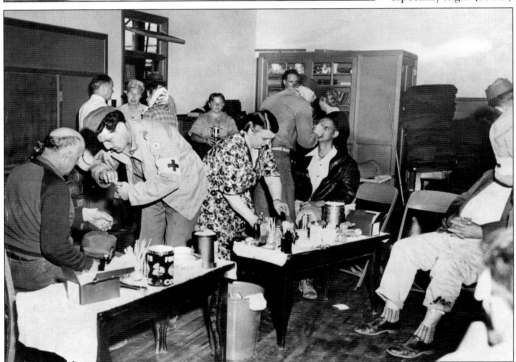

The aftermath of the explosion experienced at Port Chicago was devastating to the town, military, shipment schedules, and morale. Here, injured civilians, military personnel, and their families receive emergency first aid from the Red Cross. One month after the explosion, hundreds of enlisted men refused to load munitions until safety was addressed. Fifty African American sailors were charged with mutiny and convicted. Desegregation of Navy forces was initiated in February 1946. (SFPL.)

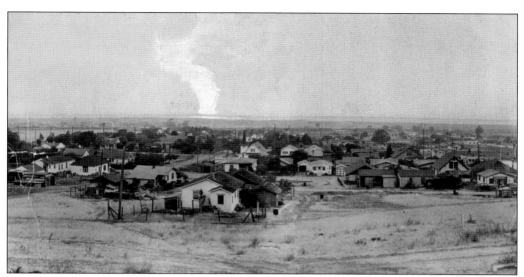

A distance photograph of the explosion at Port Chicago, as enhanced for effect by the *San Francisco Call* newspaper staff, captures what a typical Contra Costa coastal town looked like in the 1930s through the 1950s. The munitions blast was heard as far away as Lafayette and Antioch. (SFPL.)

After the explosion, there were no ships, wharf, loading dock, or warehouses left in Port Chicago. All of the military improvements were obliterated. Memory of this disaster was a factor in the Unites States acquiring the entire town of Port Chicago by eminent domain and removing its entire citizenry. The town no longer exists; the property and the munitions wharf are connected by rail to the munitions depot. The land is completely off-limits to the public. (SFPL.)

One of the best-kept World War II home-front secrets was the existence of the Joint Interrogation Center P.O. Box 651, also known as Camp Tracy, which was located in Byron. This top secret joint military command facility operated from 1942 to 1944 at the famous Byron Hot Springs. Over 3,000 Japanese prisoners of war plucked from sinking ships and islands in the Pacific were interrogated here, 44 at a time. Note the blacked-out windows. (SM.)

Eikichi Saito was one of the first Japanese prisoners of war identified as possessing information of potential strategic value to the United States. Over 38,666 prisoners were captured. Of these, 5,431 possessed information to merit travel to the United States. Only 3,500 were brought to Camp Tracy. Knowledge of Japanese line of battle naval formation, fueling depot locations, airplane manufacturing plant cities, and shipboard munitions magazine vulnerability were all learned through interrogations done at Camp Tracy. (NA.)

Seven

FUN AND FAME

Contra Costa is a frequent movie stand-in location for films depicting life along the Mississippi River, pre–Civil War folklore, and modern America. Steamboats were used here after the era of steamboats, as romanticized by Mark Twain, was long past, and Hollywood created film versions of classic literary favorites *Adventures of Huckleberry Finn* and *The Adventures of Tom Sawyer* along the San Joaquin River. Highways did not replace inexpensive water transport along the Sacramento and San Joaquin Rivers easily. Steamboats plied the waters of California, not the Mississippi. The Antioch Bridge did not connect Contra Costa to the "Netherlands of the West," as Solano and Sacramento agricultural lands were described, until 1926. The Carquinez Strait was spanned a year later in 1927 by the same construction engineers who built the Antioch Bridge. Depression-era folk singers, slapstick humor, and contemporary romantic comedies find a welcome backdrop to mimic nearly anywhere in America along the Contra Costa County waterfront.

New York may have its Manhattan cocktail, but mixology owes a local bartender, Julio Richelieu, who blended gin, a splash of vermouth, and a small olive for the first time, for the creation of the martini. A patron, possibly a gold miner, was killing time while awaiting a commute boat and asked for an alcoholic drink, something new. The barman, Richelieu, complied. "What do you call this drink?" the patron asked. "Where you headed?" replied the barman. "Martinez." "Then that is what we'll call it!" The rest is history. Variations on this martini cocktail creation story are legend.

The largest legal distillery in the West was established in Antioch in 1869 and provided bourbon, rye, and spirits to San Francisco. Jack London did his hypocritical best by extending permission to the Women's Christian Temperance Union to use excerpts from *John Barleycorn: Alcoholic Memoirs* in support of the growing anti-saloon movement. London wrote this semiautobiographical novel in 1913 while living on his yawl, *Roamer*, moored off Pittsburg. One of the largest Prohibition (1920–1933) raids in the state closed down a still located on Bethel Island. Sheriff R.R. Veale kept busy as the longest-serving sheriff in the United States. Good times were available all along the waterfront at fancy dress balls, homes, fraternal lodges, and boating holidays.

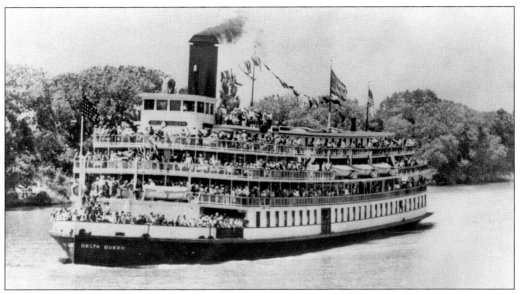

The beautiful *Delta Queen* frequently stars as the stern-wheeler immortalized in movies based on novels set on the Mississippi River. Ziegfeld Follies star, newspaper columnist, and humorist Will Rogers (1879–1935) stars in *Steamboat Round the Bend*, the 1935 film directed by John Ford. The *Delta Queen* is the featured steamboat and the bend she rounds is none other than Bethel Island. The film was a melodramatic vehicle for the ever-popular Rogers, who played a patent medicine/confidence man who saves the day. The real scene-stealers are the California steamships racing down the Stockton deepwater channel on a race to fictionalized Baton Rouge. The film was a hit, attributed in part to its release shortly after Rogers's tragic death, along with Wiley Post (1898–1935), in August 1935 in a plane crash in Alaska.

Mickey Rooney (b. 1920) (right) could have modeled his portrait of Mark Twain's Huckleberry Finn on the Lauritzen boy (below) shown here with his catch at Lauritzen's boat works in Antioch. Warner Bros. cast 19-year-old Rooney as 12-year-old Finn in the leading role of the film adaptation of *Adventures of Huckleberry Finn*, released in 1939. Once more, the reclaimed eastern islands of Contra Costa County, not the Mississippi delta, depicted the great river highway of America. From 1914 to 1940, over 40 movies were filmed in and around the Sacramento–San Joaquin delta. (Below, RV.)

Bound for Glory, a biography of folk singer Woody Guthrie, stars David Carradine (1936–2009) in the title role. It was filmed in many central California locations but uses downtown Pittsburg buildings as the backdrop for Guthrie's Depression-era adventures. The theater poster features Carradine in his Guthrie role, sitting atop a Southern Pacific Railroad car rounding San Pablo Bay en route to Selby. Readers will note the San Rafael Bridge in the background. Released in 1976, *Bound for Glory* won two Oscars—for cinematography and music.

California's author laureate of maritime life was Jack London (1876–1916). London and his wife, Charmaine (1871–1955), were frequent sailors along the Contra Costa coast and used Pittsburg as their supply depot and mail stop in the 1910s. London's semiautobiographical novel, *John Barleycorn*, was written on board the yawl *Roamer* while moored among the houseboat bordellos off Winter Island. It describes in detail the many landmarks along the inland coast and Carquinez Strait from the perspective of the main character, who falls overboard and is swept down with the tide. (PIT.)

The 43-foot *Snark* and the 30-foot *Roamer* (mislabeled here) were two well-loved ships owned by Jack London. The ketch *Snark*, named after the Lewis Carroll poem "The Hunting of the Snark," sailed the South Pacific in 1907–1909. Both ships were commonly seen sailing as far as Point of Timber Landing on Indian Slough to moor and enable London to lift a few pints at the Byron Hot Springs with his friend Capt. Charles W. Lent. (PIT.)

One of Jack London's haunts at the harbor was the Bay View Saloon. London's writing fame was not well known at this local watering hole, but his friendship with State of California Fish and Game Wardens was observed. Many locals suspiciously assumed London was a game warden or somehow associated with the government policing of the local fishing industry. (PIT.)

A common saloon advertising tool of the era was a trade or bar token. This token was good for 5¢ at the Gatto Brother's Saloon. For this price, a glass of beer or a shot of whisky, but not both, could be bought. This is similar to the "buy one, get one free" offers seen today. El Dorado (steam) Beer, brewed in Stockton, was a popular choice, as was Argonaut Whisky, which was distilled in Antioch.

Violent crime and assault were not unique to San Francisco. Wong Yang—a member of the area's large Chinese community that shrimped San Francisco Bay, built levees for swampland reclamation, and worked the canneries—was apprehended and charged with assault with a deadly weapon. One can only imagine his weapon and his grievance. He must have been an expected flight risk, as his bond in 1923 was set at $2,000 cash. That amount had the same buying power as $27,000 in 2013. (Both, CCCH.)

DESCRIPTION

148

Name _Candido Gonzales_

Alias _Near East Shore Park. 4185_

Date _June 15th_ 192.3

C. _14 yrs_ S. _24 yrs_ U.S _24 yrs._

Nativity _Spain_	Occupation _Laborer._	
Age _46._	Crime _Mfg Booze._	
Height:— _5_ Feet _2_ Inches	Size of foot _5½_	
Weight _125_	Habits _S & D._	
Hair _D. Brown_	How convicted _Police Court_	
Beard _—_	Term _300 days._	
Mustache _↗_	When sentenced _14th June._	
Eyebrows _Med Dark._	Date of sentence	
Eyes _Brown._	Discharged	
Build _stout._		
Complexion _Med_		

KT. REMARKS _Alstrom._

Marks, scars, etc. _Left hand crippled by powder._

explosion

One day a man is an honest manufacturer, the next day he is in jail. Passage of the Eighteenth Amendment and the Volstead Act introduced Prohibition in 1920. Locals of Contra Costa observed that the number of bars doubled once alcohol was illegal. Candido Gonzales found himself sentenced to almost a year in jail for manufacturing booze. In the government's defense, he had three years to observe the law before he was apprehended. His crippled hand, injured in a powder explosion, makes one wonder if his prior and qualifying chemistry experience for distilling spirits was making dynamite. Note the "S & D" listed as his habits; this was an abbreviation for spitting and drinking. (Both, CCCH.)

Keeper of the peace and at the time of his retirement in 1934 the longest-serving elected official in the United States was Contra Costa County sheriff Richard Rains Veale (1895–1935). The sheriff was everywhere in the county, tracking down illegal stills, cuffing criminals, founding historical societies, and riding his horse in Knights Templar parades. Elected in 1894, Veale originated the idea of sentencing hoboes (indigents) to time served on the rock pile, an idea that caught on throughout the nation. An inveterate local booster, he was an early promoter of creating a state highway along the shore as funded by local corporations donating both land and cash to the effort. Truck and railroad transportation eclipsed local maritime transportation soon after the highway was built. Veale is also credited with being the first to introduce and use modern steam plows and harvesters on his farm on Veale Tract. (Right, PH; below, CCCH.)

Manufacturing illegal alcohol was big business in Contra Costa County during Prohibition. This still, raided in 1922 by the county sheriff, was in full production. The first step in distillation is making the low alcohol beer or wine. The three copper containers over gas rings cook the mash. The oak barrels surrounding the perimeter of the shed hold the concoction for primary fermentation. (CCCH.)

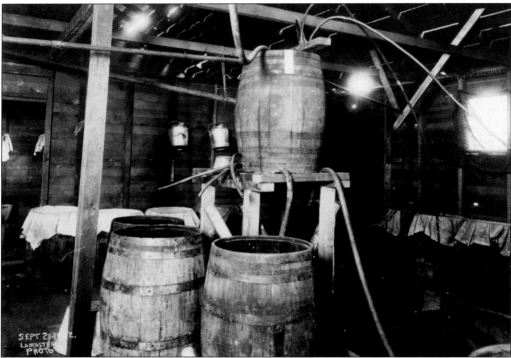

Stills could be hidden easily in the reclaimed islands, only to be discovered by telltale plumes of steam rising from the mash-cooking sheds in winter. Bootleggers could move cases of hooch from delta islands to a speakeasy in San Francisco in a few hours. River launches were originally built for agricultural commodity dealers to travel to San Francisco trade exchanges faster than their competition traveling by train or passenger steamer. Converting launch use to rum-running was but a moment's decision. (CCCH.)

The Riverview Lodge in Antioch has been a fine purveyor of good times for over 65 years. Located on a pier overlooking the water, this local establishment continues to serve cocktails and good food. No need for a speakeasy hooch here. The mixologist at the bar uses the classic martini recipe: 4/5 gin, 1/5 dry vermouth, green olive with a hand-cut and stuffed pimento pepper to garnish. Imbibing too many of these might have customers talking to the ghost of Jack London. The restaurant also specializes in homemade cioppino (fish stew) on Friday nights. Diners brought their coastal sailboat or powerboat. The patrons probably saw an oceangoing freighter heading inland to Stockton or seemingly traveling on land as it steams up the Sacramento deepwater channel.

Riverview Lodge
ANTIOCH, CALIFORNIA

Cocktails Supreme

Fresh Crab	.55	Fresh Sea Food	.60
Fresh Shrimp	.55	(Oyster, Prawn, Shrimp, Crab)	
N. Y. Count Oysters	.55	Fresh Olympia Oyster	.65
Fresh Prawn	.55	Fresh Lobster	.65
Crab Leg	.65	Fresh Clam	.65

Chowders

Fresh Clam Chowder	.25	Clam Broth (in season)	.25
Jumbo Size	.50	Jumbo Size	.50

Salads

All our Salads are crisp and fresh from our stainless steel refrigerated salad unit

Fresh Crab Louie	1.35	Combination Louie	1.45
Fresh Shrimp Louie	1.35	(Crab and Shrimp)	
Fresh Lobster Louie	1.50	Deviled Crab Salad	1.35
Fresh Prawn Louie	1.35	Old Fashioned Crab or	
		Shrimp Salad	1.35

Combination Vegetable		LOUIE SALADS	
Salad Bowl	.75	½ order	.80

Tuna Salad	1.25
Stuffed Avocado with Shrimp or Crab Louie	1.60
Stuffed Tomato with Shrimp or Crab Salad	1.25
Shrimp Salad Lorraine (served on sliced tomato pyramid)	1.50
Tomato Stuffed with Creamed Cottage Cheese	.75
Sardine Cold Plate served with Potato Salad	1.25

Riverview Special Salad		Riverview DeLuxe Salad
Green Goddess Dressing, or		Green Goddess Dressing, or
Roquefort Dressing		Roquefort Dressing
		with Shrimp and Crab
.60		.85

CHEF'S SALAD
Consists of Turkey, Ham, Cheese, Vegetables; choice of Dressing
1.65

Chilled Sea Foods

Raw New York Count (Eastern) Oysters (½ dozen)	1.35
Fresh Jumbo Prawns (in the shell)	1.50
(½ order)	1.00
Fresh Whole Cracked Crab (in season)	1.75
(½ order)	1.00
Fresh Lobster, Garni	2.00
(½ order)	1.25
Fresh Clams	1.50

FRIDAY SPECIAL
Seafood Cioppino (large bowl)	1.60
(½ order)	.95

Leo's Special Omelette
Consists of eggs, mushrooms, ground sirloin, green pepper
1.50

Clams & Oysters (IN SEASON)

Steamed Fresh Clams (Plain)	1.35
(½ order)	.85
Steamed Fresh Clams (Bordelaise)	1.45
(½ order)	.90
Oyster Stew (Olympia)	1.75
Oyster Stew (N.Y. Count, Eastern) (½ dozen Oysters)	1.10
Fried Oysters (N.Y. Count, Eastern) (½ doz. Oysters)	1.25
Fried Oysters (Olympia)	2.00
Baked Oysters (N.Y. Count, Eastern) (½ doz. Oysters)	1.35
Roast Oysters — Fancy Pepper	
(New York Count, Eastern) (½ dozen Oysters)	1.60
Oysters Rockefeller (½ dozen Oysters)	1.70
Hangtown Fry (New York Count, Eastern)	1.75
Hangtown Fry (Olympia)	2.00

Creoles

Crab Creole	1.35
Prawn Creole	1.35
Shrimp Creole	1.35
Choice of Fish in season, Creole	1.35
(Above orders served with steamed rice)	

Newburgs (EN CASSEROLE)

Fresh Crab Newburg	1.35	Fresh Prawn Newburg	1.35
Fresh Shrimp Newburg	1.35	Fresh Lobster Newburg	1.85

Au Gratins (EN CASSEROLE)

Fresh Crab au gratin	1.40	Fresh Prawn au gratin	1.40
Fresh Shrimp au gratin	1.40	Fresh Lobster au gratin	1.85
Fresh Comb. Seafood au gratin (Crab, Shrimp, Prawn)			1.75

Souffles (EN CASSEROLE)

Fresh Crab Souffle	1.75	Fresh Prawn Souffle	1.75
Fresh Shrimp Souffle	1.75	Fresh Lobster Souffle	2.00
Fresh Comb. Seafood Souffle (Crab, Shrimp, Prawn)			1.90

Curries (EN CASSEROLE)

Crab Curry	1.40	Shrimp Curry	1.40
Prawn Curry	1.40	Lobster Curry	2.00
(Above orders served with Steamed Rice)			

Deviled (EN CASSEROLE)

Fresh Deviled Crab	2.25	Fresh Deviled Prawn	2.25
Fresh Deviled Shrimp	2.25	Fresh Deviled Lobster	2.35

RIVERVIEW EXCLUSIVE FEATURE
Jumbo Frog Legs Pan Fried in Butter
2.25
Jumbo Frog Legs Saute Sec with Mushrooms2.50

FRESH HOMEMADE PIES DAILY
25c

FRENCH FRIED CLAMS
$1.85

WE ARE NOT RESPONSIBLE FOR LOST ITEMS

• FRIDAY SPECIAL •
Seafood Cioppino
(Seafood Stew)
CONSISTS OF:
Cracked Crab, Prawns, Oysters, Halibut, Sole, Swordfish, Rock Cod, Clams (in season), with Sauce Supreme.

Large Bowl	1.60
Small Bowl	.95

OUR NEWEST ADDITION
PAN-FRIED BABY LOBSTER TAILS
French Fries
Coleslaw
$2.25

SPECIAL
Fresh Columbia River
STURGEON
$1.75

This group of ladies is on board for a holiday cruise. The large, balloon-like upper sleeves of their garments date this photograph to 1885–1890. Fashion historians will date the deflation of sleeves, culminating in the clean sleeve lines made famous by the Gibson girl advertisements, to 1910. (CCCH.)

Fashionable ladies on the sand dunes surround this happy man. Their bathing suits are modest and the style dates this image to the period 1900–1910. Equally important to identifying this image is the appearance of the sand dunes, which are east of Pittsburg (Los Medaños) and in Antioch (Los Megaños). Note the presence of two piers in proximity. Every property was improved by its own landing. Real estate value was measured in riverfront feet. (CCCH.)

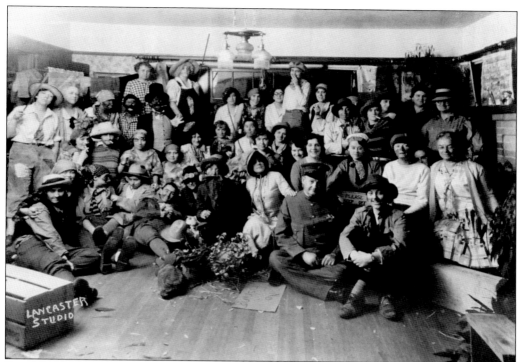

Fancy dress parties were a staple of fraternal lodges, particularly before 1970. A careful look reveals that these women are dressed as their fathers', brothers', and husbands' regular employment roles. This group picture, taken in Martinez in the 1930s, is mostly of maritime workers, farmers, and laborers. (PH.)

Turnabout is fair play as this group of lodge members displays their mothers', sisters', and wives' sense of fashion. If their apparel is indicative of women's fashion sense, then this is a prosperous community thanks to money to be made and spent from the maritime employments along the Martinez-to-Pittsburg shore. (PIT.)

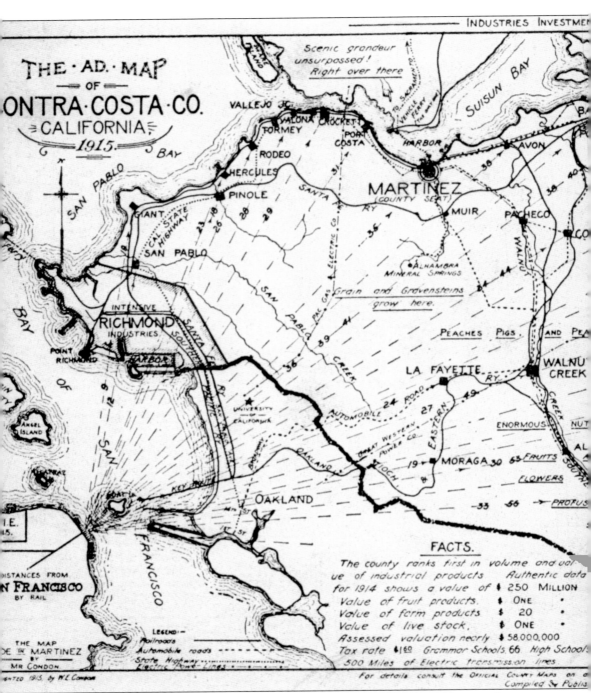

This advertising map of Contra Costa County was created as part of the publicity and promotion of the county for the Panama-Pacific International Exposition of 1915. Note the radiating arms from the San Francisco Ferry Building direct the reader and indicate distances only to communities along the shore. The first state highway built in the county parallels the shore, as does the railroad. Both roads were designed to bring local produce to a water or river landing for transshipment to

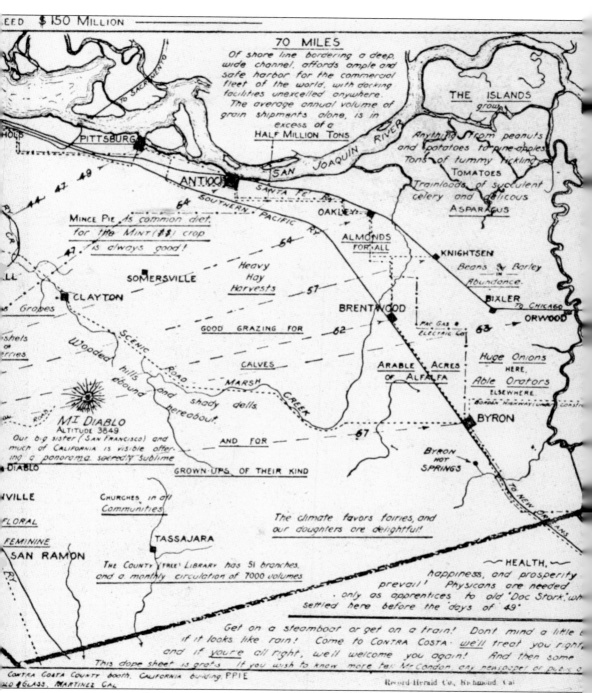

ocean vessels or coastal cruisers moving materials to San Francisco's export wharves. The railroad line serviced by Southern Pacific rolling stock is the San Pablo and Tulare Railroad bringing grains from Tulare County in the upper San Joaquin Valley. The Santa Fe line traveling through Oakley, Knightsen, and Bixler connects San Francisco to Chicago and points east. President Taft traveled to Washington, DC, and whistle-stopped the county in 1911 on the line.

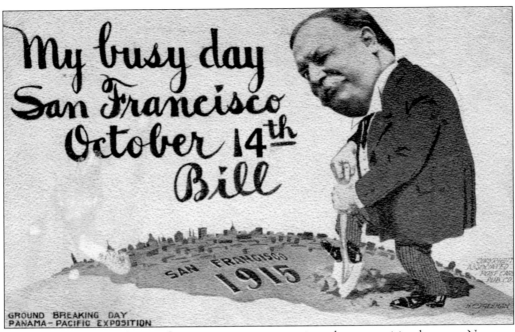

GROUND BREAKING DAY
PANAMA-PACIFIC EXPOSITION

Contra Costa citizens were swept into the competition between New Orleans, San Diego, and San Francisco to determine the host of the world's fair in 1915. Of course, San Francisco was selected for what was crowned the Panama-Pacific International Exposition. Pres. William Howard Taft whistle-stopped his way east across Contra Costa County in October 1911, extolling the fair, the citizens, and the county.

CONTRA COSTA COUNTY DAY

APRIL 3
1915

AGRICULTURAL
and
INDUSTRIAL CENTER

P. P. I. E.

Every day was a theme day at the Panama-Pacific International Exposition. April 3, 1915, was Contra Costa County Day, and community boosters ferried to San Francisco in their automobiles proclaiming the virtues of their towns. The focus of all the excitement was the California Building, modeled after the Santa Barbara Mission. Every county in the state had its own exhibit area. (PIT.)

The Ferry Building, located at the foot of Market Street, was the rendezvous point from which all visitors preceded in a convoy along the Embarcadero to the Harbor View neighborhood (the present-day Marina District), the location of the fair. A vehicle permit was required to enter the grounds and one had to purchase a day license fee to bring and use a personal camera on the site. The fair was a financial success. (CCCH.)

The California Building was one of the largest structures on the fairgrounds. The interior was a labyrinth of exhibits and booths. This real-photo postcard captures the surviving Victorian-era horror of any empty space. Each of the 58 counties had an exhibit area; Contra Costa had one of the most extensive displays. (GK.)

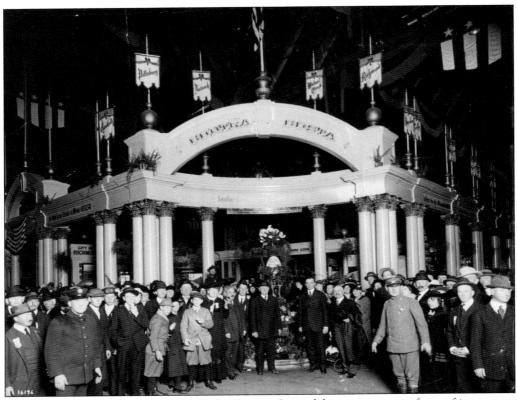

The Contra Costa delegation poses in front of its county exhibit. The placards, facades, and festoons shamelessly proclaim Contra Costa as the "Leading Manufacturing County in CAL" and its large payrolls. Sheriff Veale, appointed county commissioner to the Panama-Pacific International Exposition, center right holding his bowler hat, took pride in his home county. (CCCH.)

Chair of the Contra Costa Women's Board was socialite Mae Sadler Mead (1881–1960) of Byron. Mrs. Lewis R. Mead, as she preferred to be addressed, was the youngest county chair and an official hostess at the fair. She and her husband resided at their city address, the Fairmont Hotel, when they were not at their country resort, the Byron Hot Springs. The recently opened "Little Fairmont Hotel" at the Springs welcomed world's fair visitors to stay after their San Francisco visit.

Eight

FUTURE AND ENVIRONMENT

Maritime Contra Costa has changed dramatically from its industrial, transportation, and commercial emphases central to America's course of empire in California. Each year, the shoreline reflects a closer partnership between recreational and environmental uses. The industrial rust-belt county perimeter is transforming back to marsh and wetlands due in great part to the Save the Bay effort, started by Kay Kerr, Sylvia McLaughlin, and Esther Gulick in 1961. The organization not only stopped plans to fill in shallow areas of the bay, but is also working to protect the Sacramento–San Joaquin estuary as a healthy and biologically diverse ecosystem essential to the health of San Francisco Bay. With the largest shoreline of any county bordering the bay, maritime Contra Costa County is a critical part of that environmental commitment.

The overarching environmental component to maritime Contra Costa County is the California Water Plan and its strategic vision for statewide water distribution and use. Not since California farmers effectively stopped hydraulic mining operations in a landmark 1884 US District Court case—*Edwards Woodruff v. North Bloomfield Mining and Gravel Company*—have the Contra Costa shoreline and economy been so affected. The $14 billion California Water Tunnel Project will secure delivery of freshwater from the state's abundant north to its thirsty south and the Central Valley agricultural industry. The proposed project is designed to deliver water from the Sacramento–San Joaquin River system, provide marsh restoration, and save endangered fish species, amongst other lofty goals. Backing this project is an unexpected combination of environmentalists, delta residents, conservationists, urban water consumers, and farmers attempting to balance water quality, marine species protection, and food production.

The future for the 120 miles of Contra Costa shoreline will involve marshland restoration, minimal agriculture, ecotourism, sport fishing, government water projects, commuter ferries, recreation, boating, and bay-view residential housing. Efforts are underway to complete a 500-mile Bay Trail network that will provide recreational access to shoreline in all nine counties that touch the bay; 330 miles of the Bay Trail are already open to the public and provide a myriad of opportunities for hiking, biking, wildlife viewing, and other activities. Contra Costa County will be have one of the Bay Trail's longest segments. The four existing oil refineries are under pressure to close their shoreline operations, which would remove the largest remaining elements of the county's maritime economy. With conscientious stewardship, future maritime Contra Costa may begin to resemble a more bucolic, early-19th-century California as citizens work to restore the San Francisco estuary, which provided so much of the resources that fueled maritime Contra Costa County's economic successes.

Reinvention has been the emphasis of Contra Costa's maritime industries and shoreline development since the 1970s. Construction jobs have in part replaced industrial jobs. The 1940s Kaiser shipyards in Richmond have been transformed into a modern container ship port, a yacht harbor, and bay-view planned communities. The oil industry maintains a large presence in the community but the locus of Chevron employment is at its San Ramon campus, far from San Pablo Bay. (LOC.)

Official First Day of Issue

CONTRA COSTA WALLFLOWER

ANTIOCH DUNES EVENING PRIMROSE

Endangered Flora 1979

ArtCraft

Protection of diminishing habitat for flora and fauna has taken on new importance. The East Bay Regional Park District and East Contra Costa Habitat Conservancy are identifying and purchasing parcels of primarily riparian habitat to ensure that plants and wildlife found only along the sand dunes and unique vernal pools found in eastern Contra Costa are protected. Endangered species include the red-legged frog, San Joaquin kit fox, Lange's metalmark butterfly, Contra Costa wallflower, and Antioch Dunes evening primrose.

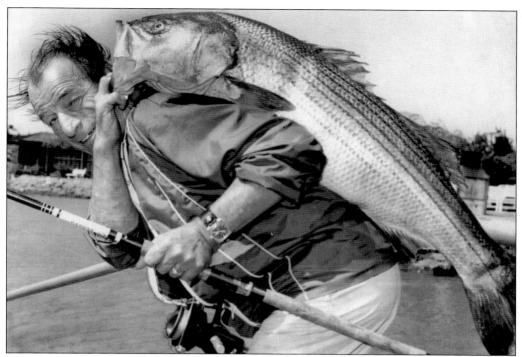

Striped bass are a favorite sport-fishing quarry in Contra Costa. Once commercially fished with gill nets, striped bass are ocean fish that seasonally return to spawn in the Sacramento and San Joaquin Rivers in April and November each year. The fish tolerate salt, brackish, and freshwater relatively well. This is an example of an actual large catch in the 1950s, estimated at 50–70 pounds, much smaller than the typical super-sized marketing image. (RV.)

A great concern for residents of the greater Sacramento–San Joaquin delta and the Suisun and San Pablo bays is that water levels and volume could be controlled to the detriment of the delta economy and lifestyle. Regulated water flow could diminish the fish stocks, farming, recreation, and livelihoods related to maritime use. Many fear that the California delta experience will be reduced to a Disneyland Frontierland adventure, as pictured here.

STOP
The
Peripheral
CANAL

Water rights as they unfold in California's political, governmental, and court systems are the overarching question that will direct the future of the littoral Contra Costa County. This is an important topic for all Californians, and Contra Costa County's role is central to the discussion. California Proposition 9, also known as the Peripheral Canal Act, was on the June 1982 ballot as a veto referendum. Voters rejected the act that would have moved water around the periphery of the Sacramento–San Joaquin delta down to Central and Southern California. The current California Water Tunnel Project proposes to build two massive water diversion tunnels underground, not surface canals, to move water to Central and Southern California. The project is highly controversial. The effect this would have on future water salinity levels is unknown. The fate of the once abundant, now endangered, delta smelt (fish) is in question. This decision will affect the future of the shoreline of maritime Contra Costa County.

SAVE THE DELTA
STOP THE TUNNELS

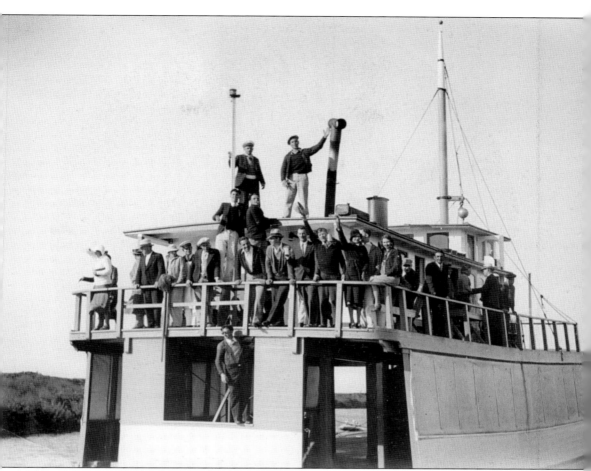

The revelers on the *Spig* look back with affection as they enjoy their passage and look forward to the future. Maritime life along the Contra Costa shore has much to offer. The inland shore is steeped in California history and important to the economic development of the nation, and it provides a rich backdrop for family life and fun. This little ship follows the same passage that John Sutter cruised on his way to found New Helvetica (present-day Sacramento) in 1840. Along the way, passengers will pass industrial papermaking plants, distilleries, rubber manufacturers, and canneries. They will experience in the swamplands of East County what pastoral California must have looked like to aboriginal people who dwelled in this land of beavers, grizzly bears, tule rushes, and oaks for millennia before European discovery. These reclaimed islands would quickly supplant native species with asparagus, celery, pears, potatoes, tomatoes, and bounty destined for export and feed the world. Enjoy and continue our Contra Costa County maritime heritage. (PIT.)

Bibliography and Additional Resources

Akers, Scott Roger. "A History of the Grain Trade in Contra Costa County, 1859–1910." Master's thesis, San Diego State University, 1971.

Blatman, Ron. *Saving the Bay: the Story of San Francisco Bay* (2009) DVD

Bohakel, Charles A. *The Indians of Contra Costa County: The Costanoan and Yokuts Indians.* Amarillo, TX: P&H Publishers, 1977.

Bolton, Herbert E., ed. *Fray Juan Crespi: Missionary Explorer on the Pacific Coast, 1769–1774.* Berkeley: University of California Press, 1927.

California Department of Water Resources. *Sacramento San Joaquin Delta Atlas.* Sacramento: California Department of Water Resources, 1993.

Delgado, James P. *To California by Sea: A Maritime History of the California Gold Rush.* Columbia: University of South Carolina Press, 1990.

Emanuels, George. *California's Contra Costa County: An Illustrated History.* Fresno, CA: Panorama West Books, 1986.

Hattendorf, John B., ed. *The Oxford Encyclopedia of Maritime History.* New York: Oxford, 2007.

Historic Record Co. *History of Contra Costa County, California, with Biographical Sketches.* Los Angeles: Historic Record Co., 1926.

Hulaniski, Frederic J., ed. *The History of Contra Costa County, California.* Berkeley, CA: Elms Publishing Co., 1917.

Leale, John. *Recollections of a Tule Sailor.* San Francisco: G. Fields, 1939.

London, Jack, and Harvey Dunn. *John Barleycorn.* New York: Century, 1913.

Lyman, George D. *John Marsh Pioneer, the Story of a Trail Blazer on Six Frontiers.* Chautauqua, NY: Chautauqua Press, 1931.

MacMullen, Jerry. *Paddle-wheel Days in California: By Jerry MacMullen.* Palo Alto, CA: Stanford University Press, 1945.

Munro-Fraser, J.P. *History of Contra Costa County, California.* San Francisco: W.A. Slocum and Co., 1882. Reprint, Oakland, CA: Brooks-Sterling Co., 1974.

Purcell, Mae Fisher. *History of Contra Costa County.* Berkeley, CA: Gillick Press, 1940.

Smith & Elliott Co. Illustrations of Contra Costa County. Oakland, CA: Smith & Elliott, 1878. Reprint, Sacramento, CA: Sacramento Lithograph Co., 1952.

Smith, Robert H. *Smith's Guide to Maritime Museums of North America.* Del Mar, CA: C Books, 2006.

Thompson, John. "The Settlement Geography of the Sacramento-San Joaquin Delta, California." PhD diss., Stanford University, 1957.

University of California Publications in American Archaeology and Ethnology. Vol. 23, no. 2. Berkeley: University of California Press, 1926.

www.cocohistory.com

www.ebparks.org/parks/big_break

www.ecchs.net

www.nps.gov/safr/historyculture/museum-collections.htm

www.nps.gov/safr/index.htm

www.PittsburgHistoricalSociety.com

www.RichmondMuseumofHistory.org

www.SavetheBay.org

www.TheDeltaWetlands.com

About the East Contra Costa Historical Society and Museum

The East Contra Costa Historical Society, founded in 1970, is an all-volunteer, nonprofit organization whose mission is to collect, maintain, preserve, and protect historical artifacts and information of cultural and historic value relative to the area of eastern Contra Costa County, California.

The society's museum, the Byer/Nail House, is maintained and preserved to promote public awareness, education, and appreciation of the heritage of East County. It is a two-story 1878 home furnished with period rooms capturing domestic economy in the late 1800s. The museum is located in Knightsen Township, near the city of Brentwood, just 50 miles east of San Francisco. Its collection tells the story of small-town and agricultural life along the San Joaquin River delta.

You will enjoy our exhibits, self-guided tours, curated programs, and living history events. The society provides a showcase of photographs, artifacts, farm equipment, and other pioneer living furnishings for the visiting public. In addition, we offer an interactive educational program tailored to kindergarten through high school student students. The society's archive of documents and images provides local historians and genealogists with a great historical resource. The periodic newsletter chronicles local historical incidents of note and calendars upcoming community events. Selections of local history publications are available for sale.

The East Contra Costa Historical Society welcomes all to join our organization. We are located at 3890 Sellers Avenue, Knightsen, California 94548. Our mailing address is P.O. Box 202, Brentwood, California 94513. Please contact us for more information and our seasonal hours. Our website is www.ecchs.net, telephone number (925) 634-0917, and e-mail ECCHS@ymail.com. We welcome your visit.

Discover Thousands of Local History Books Featuring Millions of Vintage Images

Arcadia Publishing, the leading local history publisher in the United States, is committed to making history accessible and meaningful through publishing books that celebrate and preserve the heritage of America's people and places.

Find more books like this at
www.arcadiapublishing.com

Search for your hometown history, your old stomping grounds, and even your favorite sports team.

Consistent with our mission to preserve history on a local level, this book was printed in South Carolina on American-made paper and manufactured entirely in the United States. Products carrying the accredited Forest Stewardship Council (FSC) label are printed on 100 percent FSC-certified paper.

MADE IN THE USA